PROP MAN

**From John Wick to
Silver Linings Playbook,
from Boardwalk Empire
to Parks and Recreation**

—

**Props and Essay
by Ross MacDonald**

Text by Steven Heller
Princeton Architectural Press, New York

Published by
Princeton Architectural Press
70 West 36th Street
New York, NY 10018
www.papress.com

ISBN 978-1-64896-112-0

Production Editor: Stephanie Holstein
Designers: Paul Wagner and Natalie Snodgrass

Library of Congress Control Number: 2021947226

Contents

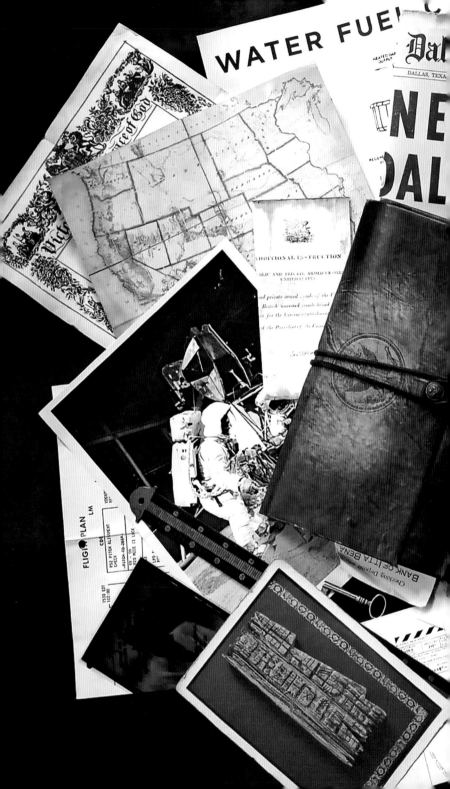

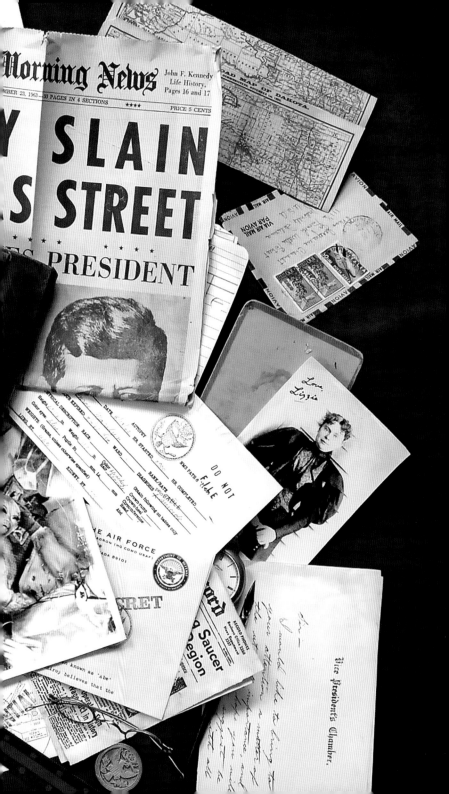

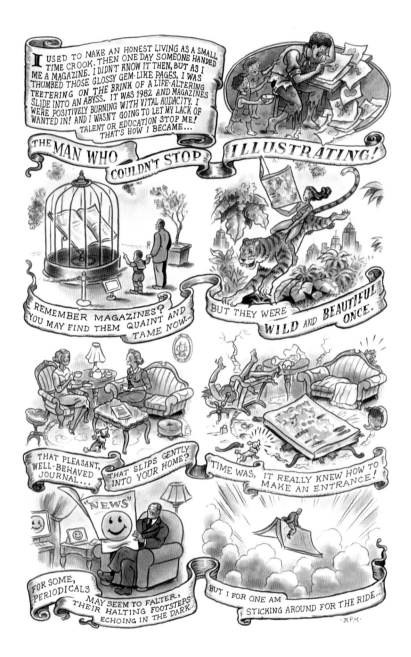

A poster advertising an exhibition of illustrators' sketches.
The panels are inspired by rejected sketches from past jobs.

Ross MacDonald: Drawing Comes First
Steven Heller

Comic books did not save Ross MacDonald's life,
but drawing them prevented him from going insane
after he was misdiagnosed with incurable leukemia.
At seven years old, he was bedridden for six months
before doctors discovered that he actually had
rheumatic fever, which left him temporarily unable to
walk. With no hospitals close to his remote Canadian
hometown of Seaforth, Ontario, he was the only
patient in the sunroom of a Victorian mansion turned
into a nursing home.

His Florence Nightingale, a volunteer candy striper,
lavished him with attention and gave him old comics.
"I spent most days reading *Classics Illustrated* and
drawing," he says. Eventually he recovered and "got
to keep the comics!"

His parents "practiced benign neglect," MacDonald
says, so he was free to pursue his own interests. The
single important lesson he learned from his mom and
dad was that "not knowing how to do something was
no reason to not do it." His parents both worked by day
at a local potash mine, but on the side his mom made
clothes and reupholstered furniture; his dad main-
tained the vending machines at the mine (and "with
Uncle Mac, they invented all kinds of devices to sort
the big bags of coins they collected every night").
His dad went to night school at fifty, earned his high
school diploma, and became a chartered accountant.

At sixteen years old, after dropping out of high
school in Colonsay, Saskatchewan (population 450),
MacDonald escaped to Toronto. "I think my parents
were disappointed that I didn't graduate high school
and go to college. No one in my family had." Instead,
he took a job as a handmade papermaker that led

to working as a printer at Coach House Press, a hangout for experimental writers and artists. "My first night on the job I printed a book of poetry by Michael Ondaatje, who was on the Coach House editorial board." He also made comic drawings, played with typefaces, and learned to run a letterpress. "We created fake college diplomas for fifty bucks," he recalls. "I wish I'd made one for myself."

Rather than pursuing a formal education, in 1974 MacDonald and his elder brother, Robert, a designer at the University of Toronto Press, were interested in letterpress after having apprenticed with some die-hard printers. They bought a flatbed repro press, tons of vintage type, and founded Dreadnaught Press, where they printed wood type broadsides and linocuts. This gave MacDonald the confidence to become an artist. He also wrote and illustrated his first nonfiction children's book, published by Bantam and released in several foreign editions. The initial advance was a surprisingly generous $30,000, which he invested in the Dreadnaught cooperative. He also took the pseudonym Rudi McToots, because the famous detective novelist Ross Macdonald (actually the nom de plume of Kenneth Millar) was still alive.

When he decided to leave Dreadnaught Press to forge his own future, MacDonald was broke. To make ends meet, he became a house painter along with two artist friends. When not painting, they founded a rock band called the Boinks, doing occasional grant-funded poetry, art, and music gigs. Their sci-fi–inspired tunes were unique enough to attract national media attention, garner a regular spot on a weekly national radio show, record an album, and create funny music videos for a kids' TV show, *Kid Vids*. The songs, written by his bandmates, were catchy, funny, and subversive. MacDonald drew six-foot-tall drawings on stage for each song, as well as art for their album and books. He also performed in costume as various characters

from the songs, constructing them from old boxes, foam rubber, fun fur, and house paint. These costumes included dancing robots, bananas, hot dogs, a fried egg, and a three-headed creature. He also conceived and painted sets and props for their videos and performances. "This was my first experience in prop work," he notes.

MacDonald did a few illustrated book projects during the eighties, but admits that illustration was then just "one of the hustles I had going to pay the rent." Some illustrator friends, however, encouraged him to contact magazine art directors to get more work, which he did. The first, Robert Priest, an internationally recognized magazine designer who directed the big color weekend magazine for the national newspaper *The Globe and Mail*, "was very kind but not interested." Second on his list was Rob Melbourne, the art director for the weekend magazine supplement in the other big paper, the *Toronto Star* (where Superman artist Joe Shuster had worked as a kid, and served as the model for the *Daily Planet*). "When I said that Priest had turned me down, he took great pleasure in hiring me." However, the star-is-born break came when MacDonald showed his portfolio to Barbara Solowan, art director of a new glossy mag called *Toronto*, also published by *The Globe and Mail*. "She hired me to do two large illustrations and some spots for an article on this new thing called *global warming*. When that issue came out, other art directors started returning my calls."

MacDonald's style humorously recalls the syrupy, idealized, all-American innocence of thirties and forties children's books. As a kid, his family owned a twelve-volume encyclopedia set called *My Book House* that was published in 1930, packed with inspirational stories and Depression-era graphics by the best illustrators of the day (including artists for *Dick and Jane*). "I grew up not just reading them, but utterly

absorbing every page into my DNA." When he first sought magazine work, he still had access to Dreadnaught's printing press, and so was able to produce multicolor linocuts in the *My Book House* style that were originally watercolor drawings. "My weird hybrid was partly a marriage of convenience; I had been doing linocuts for years, and it was a good way to create multiple copies for promotion. I don't think anyone else was doing anything like it at the time, and somehow it clicked." He adds that there was an "irony in using a passé *Dick and Jane*–vibe to illustrate modern eighties content."

MacDonald still consciously references early Siegel and Shuster Superman art and other comic book nostalgia, like Charles Atlas ads. When developing his style, there was something about "the goofy innocence of Superman comics that appealed to me more than the bombastic Marvel world." Both were well-drawn, but the Marvel comics—Spiderman, Silver Surfer, et al—were set in the present time, and the Superman comics felt like they were still set in the forties. Marvel comics were about teen angst and urban unrest and galaxy-destroying superbeings, "while Superman was just trying to keep Lois Lane from figuring out that he was Clark Kent. They were corny as hell, but that was part of the appeal somehow. I used to reread the Charles Atlas ads until I had them memorized."

MacDonald honed a strict process over the years. When he starts an illustration, it is a mental exercise. He "thinks of ideas and if they don't work rejects them" without bothering to put them on paper. When he does a sketch, sometimes it comes to life with the first doodle and other times it can take hours to come up with something. "I've had to learn that it's just part of the process and I can't fight it," he explains.

Drawing small (a little over an inch square) allows him to focus on composition and concept. When

sketching large, on the contrary, "I often get caught up in loving some little detail, like a hand or facial expression, and I lose sight of the composition. If I see something that looks promising, I'll go over the light blue pencil with an HB mechanical pencil, making further little changes. When I get a tiny sketch I like, I'll then scan it with a scanning app on my iPhone, blow it up to maybe three or four inches and send it to a printer. Then I'll take that print and trace it on the same pad, sometimes right next to the first thumbnail. That tighter sketch gets blown up again, and I trace the final art from that on a light table."

Although illustration is his first love, MacDonald's work at his Brightwork Press in Newtown, Connecticut, gives him enormous pleasure. When he moved to New York in 1987, he bought a 12 × 18 in. flatbed Poco press and a couple of fonts of type and set it up in a corner of his Tribeca studio. "I did a few pieces on the Poco, and quickly realized that this was scratching an itch I didn't know I had. I started filling up my little studio with type and specimen books. My wife, Lucy, and I then had a year-old kid in a one-bedroom apartment, it was getting obvious something had to give. We found an old house in Newtown with a barn, and now we had room for family and I had room for presses and type. I printed promo pieces like mad, sent them out to art directors and started getting display type and design jobs."

MacDonald enjoyed spending endless hours poring over type specimen books, books about the history of printing presses, type design, and type manufacture. "Type and presses played a role in the American Revolution, and one of the things the colonists objected to was that they were forbidden to cast their own type," he relates. "Early in the revolution, they tore down a lead statue of King George III, melted it down, and cast the first American type."

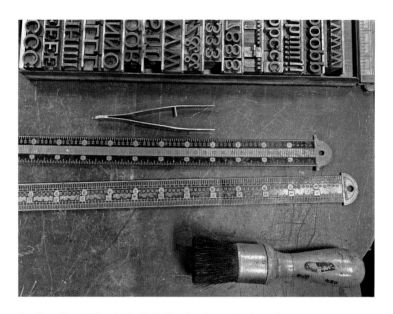

A galley of type (48 point *Latin Antique*) and some tools on the imposing stone in the letterpress shop.

Most of MacDonald's type is nineteenth-century vintage, which he tries to use in more contemporary ways. "When you're working with nineteenth-century type, and with the right angles imposed on you by the type itself and the bed of the press, there's only so much you can do. The thing of mixing typefaces and type sizes in a single word or line has been done by plenty of designers who work with letterpress. I've experimented with putting type on angles and curves, something that was uncommon in nineteenth-century letterpress printing, or with fluorescent inks. But I don't mind when my stuff has that sturdy, early design feel that I love."

"Semi-comfortable" in the digital world, MacDonald designs a lot of his movie work digitally, sometimes adding digital color to line art illustrations or making corrections and color tweaks on painted pieces. He does not sketch on a tablet or use a Cintiq; he

never learned InDesign or even Illustrator, but uses Photoshop for everything, even design. "When I make props for period shows, a crisp, hi-res look doesn't always suit the material. When I hire outside designers to help with laying out pages for a 1940 newspaper, for example, I often have to explain that those papers weren't designed, the pages were set really fast on Linotype machines and Ludlows and assembled in the comp room by guys in dirty aprons. They used the same text font—often Linotype Ionic—and chose from a handful of display fonts that the particular paper used: Chelt, Bodoni, Alternate Gothic."

Making film props began when he worked on the comedy *Baby's Day Out* (1994), for which the title sequence features the turning pages of a children's book. Since the illustrations are really tied to the story, he had to work on set in Chicago for six months. When he returned to New York, "I assumed I'd probably never work on another movie again. How often did they need book illustrators? And that was true for ten years. But the people I had worked with on *Baby's Day Out* went on to work on many other movies, and one day a prop master asked if anyone knew of someone who could make an old book." He got the job for the film *The Alamo* (2004) figuring out what the Texan William Travis's 1830s journal might have looked like. "Because I had been collecting, hoarding, really, a lot of old books and paper, I was able to give him lots of information." For MacDonald, forgery is fun and the research—finding examples of obscure documents and figuring out how to replicate them exactly—is very satisfying.

MacDonald identifies mainly as an illustrator, yet proudly lists "prop designer" in his long multi-hyphenated job description of illustrator-author-designer-letterpress printer-prop designer. "It's great to take a break from one thing and work on something entirely new," he says.

Prop Man

Interview by Steven Heller

Heller: Since you've become a prop expert, you've gone down a rabbit hole of precise, accurate, flawless recreation. How does this obsession manifest in your life?

MacDonald: I can pound your ear flat on any number of esoteric subjects I've learned, like how the origin of lucky number dream books is tied to Chinese acupuncture charts, or the date of the first telephone handset or camera flashbulb (1927 for both). Or how the history of type casting in America ties into the American Revolution. I can usually guess the approximate date of a piece of period ephemera and tell how it was typeset and printed. I know how to cut a quill pen, when the first steel pen nibs and fountain pens became available, when people stopped using the long S in writing and printing, when the first machine-made paper was made, when and where the first perfecting web press was invented (1870, New York!).

I've always wanted to store that kind of esoteric knowledge, but there is a limit to my patience. Do you enjoy it as much as it seems?

I've built up a vast base of obscure knowledge over the years. It's necessary for the work I do, but I also find it totally fascinating. The search will take you to magical places that you would never otherwise find on your own.

Well then, how deep do you dig to achieve true accuracy, rather than folklore?

Pretty deep. It can be easy to be misled if you just look at the first couple of hits when you do a web search. Many sites swipe content from each other, so the same glib erroneous facts can get repeated all over. Even museum web sites can have misleading info.

And although it seems that everything ever done is chronicled online, the fact is that there are tons of dark areas on that map.

What, for instance, are some of the holy grails?

Certain things that seemed too mundane to be worth documenting are often the ones I have to find—period driver's licenses, tickets to certain venues, boring paperwork—things that only a few people saved. If you get lucky, you can find them on eBay sometimes. For *The Wizard of Lies* (2017) on HBO, I had to find a stack of *Wall Street Journal* newspapers from the week of Black Monday in 1987. I had tear sheets of illustrations I had done for the *WSJ* in 1988, but that wasn't enough to recreate accurate examples. I called several art directors who I had worked with at the *WSJ* and discovered that their archive had been lost in 9/11. I managed to find bad photos of a couple of partial pages, but that was it. Just when it started to look like I was going to have to slink off in defeat, I found a complete set of the papers for that week on eBay. Some random guy in the Midwest had saved them and offered them for sale at just the right moment.

How fortuitous. What else has turned into something of a miracle?

For an episode of *Boardwalk Empire* (2010–14), the script called for two characters to buy lottery tickets while at a café in Cuba. Not only did I have to research what Cuban lottery tickets from 1930 looked like, I had to find out how they would have been sold. I managed to buy some *lotería* tickets from that era, but getting further info was tough. I dug and dug and eventually found a *Colliers* magazine article from 1930 that gave a detailed description of how the Cuban lottery worked. Street vendors, often young boys, would carry uncut sheets of tickets around to the tables at cafés and bars. Patrons would pick out a ticket, possibly using a dream book to help choose a number, and the

boy would cut the ticket from the sheet. When you see that scene, it all looks very natural and believable, but the action was built on a solid base of detailed research.

It sounds like the scene in the movie *The Treasure of Sierra Madre* (1948) when a very young Robert Blake sells a ticket to a down-and-out Humphrey Bogart. Tell me, how much of this is make-work versus how much detail is demanded by the director of any given film?

Some directors care more about accuracy than others. Tarantino didn't demand absolute period accuracy on *The Hateful Eight* (2015). We might show him what the correct thing looked like, but if he saw something that he liked that wasn't dead accurate, he might go with that. For *The Plot Against America* (2020), the showrunner was David Simon. He was a former newspaperman—he worked for twelve years on the crime desk at the *Baltimore Sun*. So all of the newspapers I made for the show had to be accurate down to the tiniest detail: size, ads, fonts, copy, photos. Not only for the front page, but all of the interior pages as well. I bought a bunch of period-correct newspapers—the *New York Times*, *Post*, and *Daily News*, the *Philadelphia Inquirer*, the *Pittsburgh Post-Gazette*, the *Jewish Daily Forward*—and I did well over thirty newspapers in all. I scanned in a lot of the ads for each paper and sorted them into files by paper and by column size. I had a friend type up copy for all of the filler articles, and David Simon and other writers on the show supplied copy for the hero articles. I put together a list of the fonts used in each paper.

Can you do this alone or do you hire others to work with you?

I enlisted the help of a couple of designer friends who had worked in newspapers and magazines, James Reyman and Jack Tom, and gave them a crash course in how newspaper pages used to be set up

by editors in ink-stained aprons. Eric Rosenberg, the supervising graphic designer on the show, was a former magazine designer as well, and had a lot of experience in creating accurate graphic props. Then I had most of the papers printed at my small-town newspaper. It was a huge undertaking and months of rush work, and of course we see them on-screen for mere milliseconds. But we know we got them right, and that's what matters.

I recall that you had to teach Keanu Reeves how to bind Victorian books and make gold embossing for a scene in the first *John Wick* movie (2014). How'd that come about?

The *John Wick* writer and directors had created a backstory for Keanu's character. He was a legendary contract killer who became bereft after the death of his wife and retired from the killing business. He had a workshop full of old books and bookbinding equipment in the basement of his house and planned to spend his days in quiet reflection while pursuing his first love: collecting and restoring nineteenth-century children's books. The books and equipment were rented from me, and I spent time with Keanu training him. At first, we weren't sure what he'd actually do—what looked good that he could learn quickly. He learned to shave leather, stitch book signatures, and a few other things, but it was decided that he should do some gold stamping. I was on set as technical advisor for a few days when they were shooting those scenes.

If I recall correctly, you also became his "hands double." How come?

Gold stamping requires that the tools be heated up to around 350 degrees on an industrial hotplate. For the longer shots, he went through the motions with cold tools with the hotplate off—possibly for insurance reasons, I don't really know. Then they

wanted close-ups of the stamping. We realized that he and I had the same size hands, so I put on his ring and watch and heated up the hotplate and tools and really stamped the books. It's slightly surreal having a roomful of people and equipment intensely focused on your hands when you're trying to do something finicky. When I breathed, I kept blowing the little bit of gold leaf away, so I stuck a bit of tape on it to hold it in place. Keanu called me on it because he had the same problem and I hadn't taught him the tape trick.

This has obviously made you a historical reenactor. What were your most challenging assignments?

One of the biggest challenges was another *Boardwalk Empire* assignment—essentially creating Victorian child pornography. There's a scene in the final season where we see the main character, Nucky Thompson, as a young boy. He's working in an Atlantic City hotel and walks into his boss's office and sees an array of semi-erotic photos of young girls on the desk. That silent moment is when he (and us, the audience) learn something profound about his boss's character that plays out later in life for them both. It was an important reveal, and the director wanted the photos to instantly convey the fact that the boss, known as the Commodore, was a pedophile. We see that fact register on young Nucky's face. But how to create semi-erotic photos of children? That's not exactly something you want to have in your online search history, should the FBI come calling. Nor did I want to go there. I was familiar with a couple of Victorian photos that seemed slightly odd by modern standards, like Charles Dodgson's photos of the young Alice Liddell. I showed those to the director, but was told the photos needed to be "more erotic." They didn't want the photos to depict actual sex, but to be suggestive enough to really sell the idea that the Commodore had an unhealthy interest in young girls. I called an archivist

I know at the Beinecke Library and asked for help. She suggested a couple more examples, but those didn't make the cut either. I finally solved it by altering photos of women. Essentially de-aging them. I made sure that they were all draped in fabric or otherwise clothed enough to not be too revealing, but there was no mistaking what the intent of the photos was.

How often do you have to actually be on a set to ensure your prop is used correctly?

Hardly ever. I sometimes have meetings with a prop master and have sometimes sent videos or had phone calls with actors or props people, describing how to use something. I've also prepared written dossiers to help them understand how to look like you know your way around a Victorian print shop, for instance. I try to avoid going on set if I possibly can. It's usually impossibly long hours standing around.

What happens to these artifacts after the filming is completed?

They're the property of the studio. Some get tossed. Some "walk off the set" and get grabbed as souvenirs by crew members. Sometimes the studios use them for promotion: they created a road tour for some of the *John Wick* props, and my Book of Secrets was displayed in the Library of Congress and in the Walt Disney Family Museum (made for *National Treasure: Book of Secrets*, 2007). But mostly they're sold to prop auction houses. You can often pick up props from shows and movies for a reasonable amount.

Is it tempting to go make counterfeit artifacts or inadvertently produce something that can be sold as such? Do you place a mark or brand that lets others know these are recreations?

I've had some weird requests over the years that seemed pretty dubious. I was just contacted by someone who claimed to supply props to film sets

but who was clearly not familiar with how film shoots work. Prop collectors have tried to sell recreations as "screen used props." "Screen used" means that the item appeared on the screen—in other words, it was the prop that was handled by the actor and appears in the final cut of the film. That's the gold standard of prop collecting. The next step down is "production made"—a prop that was made during production but may not have appeared on-screen. When I sell a replica of a prop I created, I make sure it's clear that it's a replica, and I provide a certificate of authenticity that states that. I also often sign and date them in a hidden spot. That hasn't stopped shady collectors from trying to resell them as screen used. The prop collecting community seems pretty good at policing these bad operators. I've been contacted a few times to authenticate a prop.

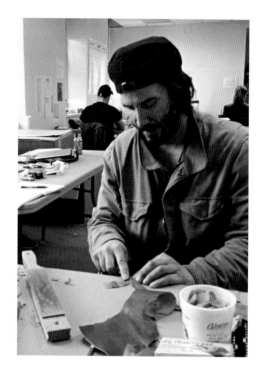

RIGHT:
Keanu Reeves learning how to shave leather for binding books.

BELOW:
Filming of a book-binding scene for *John Wick*. These scenes were later cut from the movie.

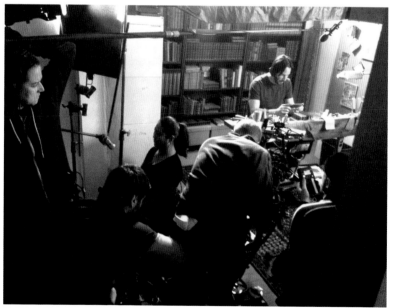

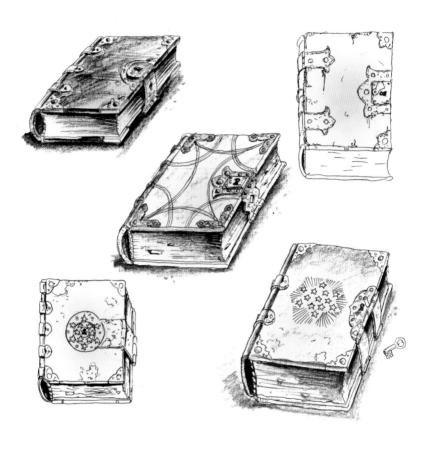

First thumbnail sketches of the
Book of Secrets for *National Treasure:
Book of Secrets* (2007).

The Book of Secrets

Ross MacDonald

The Book of Secrets, for the movie *National Treasure: Book of Secrets* (2007), might be the most involved prop that I've worked on.

In November 2006, I got a call from prop master Ritchie Kremer about an upcoming movie project: the sequel to *National Treasure* (2004). The producers had just sold the movie to Disney Studios and production was going to start up in early 2007. At that point, there wasn't a full script yet, just an outline, and a lot of the movie ended up getting written on the fly, as they were shooting.

I had previously made some big book props for Ritchie for *King of California* (2007) and *The Legend of Zorro* (2005). Knowing from those experiences how much work the titular Book of Secrets might be, we wanted to get started as early as possible. Ritchie outlined the basic idea: when every president of the United States is sworn in, each is given an *incredibly* confidential notebook which contains all of the secrets too troubling to keep bottled up inside, those that are too unspeakably terrible, shocking, or astonishing to be revealed to *anyone, EVER*. A sort of presidential confessional. At that early point we had no script, so we knew nothing else about the book, what would be in it, or how it would be shot.

I sketched a few rough thumbnails, just so we had something to get the conversation going.

I was going for something big and impressive looking: huge, thick, leather bound, with lots of gnarly hardware. They liked the general idea but decided that it needed the Great Seal to telegraph "president" (the Presidential Seal, which is based on the Great Seal, came along later, around 1850). I also wanted to cut

back on the hardware and make something simpler, but with an impressive lock. I felt like the heft, the seal, and the lock were enough to sell it.

I put together a show-and-tell presentation for the director with a couple of large leather-bound covers with a gold-stamped seal, sample papers and pages, documents, etcetera.

I thought it would be cool to have lots of color on the pages, featuring hand-drawn maps, cryptic diagrams, and ciphers. But the director wanted the pages to have just writing, no images. He also wanted additional loose inserts scattered throughout the book: loads of photos, newspaper clippings, letters, notes, and diagrams. I was told to just come up with secret documents, without any direction on what those secrets should be. I dug into the research on conspiracy theories about Area 51, the Kennedy assassination, D-Day, government ESP research, and lots of other fun stuff. I started making dozens of fake letters, reports, photos of alien autopsies, moon landing photos, etcetera. I added lots of intriguing real stuff that I had unearthed in my research, including exhibits from the Warren Commission report on the JFK assassination, aerial photos of Area 51, the flight plan of the first moon landing, and real newspaper clippings of UFO sightings in Roswell, Kennedy's assassination, Al Capone's trip to Alcatraz, and the sinking of the Titanic.

Meanwhile, the shooting started while the script was still evolving. Early on, it was planned that the large, locked book would be in an attaché case handcuffed to a Secret Service agent's wrist. Then they changed their mind. It would have been too complicated to figure out how Nicolas Cage could separate the case from the agent (lockpick? machete? lots of Crisco??). After a couple more zigzags, they decided that the book would be hidden in the Library of Congress. At first, they planned to hide it in the base

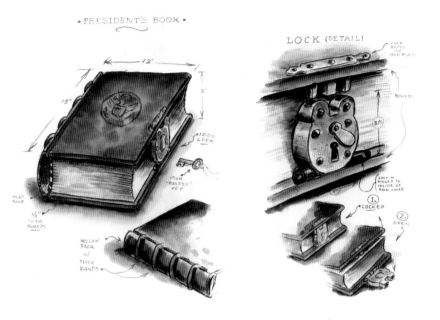

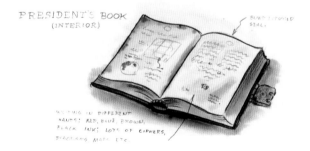

Early sketches of the Book of Secrets for a show-and-tell presentation for the director.

of a statue. I was then presented with sketches of how the statue and the book would look. They were based on my sketch but done by a concept artist on the crew. In the great Hollywood tradition of Big Scary Movie Books, the new design had gotten a little over the top.

At this point I had hundreds of pages of extra insert documents and was fielding requests for more. I told Ritchie that my one worry was that when we stuffed them all into the pages of the book it would be impossible to close and lock it. I joked that we'd have to rename it the "Shoe Box of Secrets." Luckily, things zigged again and the new hiding spot for the book was on the shelves of the library, and the space was so small that the huge locked book plan was nixed. I pitched the idea of a small, leather portfolio-style cover that tied shut with a cord. I pictured a design that was simple, that might look like George Washington had it made as a regular notebook. With the wrap cover, it would be flexible enough to stuff with documents. By concealing it in a clever hiding spot with a combination lock, there would be no need for locking hardware on the book itself, and no need for actors to fumble with keys and latches (there's often a conversation about the pros and cons of big complicated locks and latches on prop books). It was also now small and light enough that they could hold it in their hands, rather than having to plonk it on a table. There would also be more flexibility in framing shots of the actors looking at the book.

I had already compiled many files of presidential writings, so now I just needed to print and bind the book. With a prop book there's typically a "hero" section: the page or pages that are in the script and need to appear on the screen. The rest of the book can be blank or, my preference, filled out with filler pages that aren't hero, but match the hero pages and look good in the odd chance that the actor ad libs flipping through the book to find the hero page, something

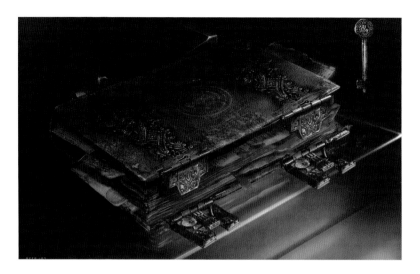

Crew concept artist's digital rendering of the Book of Secrets.

that happens plenty of times. But since the script was constantly evolving, I decided that we should have book pages for every president just in case.

It was probably more difficult to find examples of each president's handwriting on the internet in 2007 than it is now. I found letters, handwritten speeches, and notes from about two-thirds of the presidents, but others were tough to locate. I contacted rare-document dealers and pretended I was an interested collector so they would send me photos of rare documents to authenticate, and with those I was able to fill out the rest of the book. Each of the documents needed hours of work in Photoshop to clean them and separate the old, faded writing from the dark stained paper. I never print background color on my prop documents. I prefer real paper color and various hands-on aging techniques. I think it just looks better.

Once the book pages were printed and bound, I finished the inserts. Each was on a different paper, on old stock I had rescued from defunct print shops, photo paper, handmade paper, old laid paper,

etcetera. Each document was aged and stained in a different way. The older ones needed to look like they might have spent time in a saddlebag strapped to a sweaty horse or survived a shipwreck. Some had handwritten cryptic markings or rubber stamps (Eyes Only, Copies Destroyed, File Under, etc.). While some of the "secret" documents are pretty blatant—photos of the alien autopsy and the moon landing being shot on a sound stage, or a plan for a water-powered fuel cell—many others offer subtle hints of possible mystery: a photo of Lizzie Borden inscribed "Love, Lizzie," an unopened air mail letter, a found nineteenth-century cabinet photo of an Asian baby, a real 1947 discharge form from a Roswell, New Mexico, hospital that I filled out for someone named "Abe," and a still from a home video which inadvertently recorded the assasination of President John F. Kennedy, known as the Zapruder film, showing a circled shadowy figure in a reflection near the film sprocket.

During this time, I was also working on other elaborate books and props for the movie, including a replica of John Wilkes Booth's diary for other scenes. All of the books involved extensive research, director show-and-tell presentations, interior illustrations, and printing and binding. In the case of Booth's diary, I made six of the elaborate leather wallets, and printed and bound more than one hundred and twenty of the interior books. So by March it had been several months of long days and seven-day weeks, and I was just finishing the Book of Secrets and the Booth Diary when I got a call from Ritchie that they needed them on set in Washington…*that night*. There was no time to ship it. I had to drop everything, grab my go-bag (filled with stuff I might need to make prop documents: art supplies, paper, rubber stamps and stamp pads, etc.), and catch a train to Washington, DC. I got into Union Station at about 6 p.m. and grabbed a cab. One problem—I had only a vague idea of where I was going.

I told the cab driver that I was headed for "somewhere in Bethesda" and that I would call in for further directions.

I called Ritchie. He had no idea where they were. He told me to call someone else, who also had no idea, and told me to call someone else. This went on for some time. Every time I called a new person, I got the same question, "How did you get this number?" The problem was that the crew were from Los Angeles, staying in a hotel, and being driven to and from the various locations in white vans. They seemed to have no idea where they were either. Someone gave me a general description: their base camp was a bunch of white tractor trailers parked in the lot of a strip mall near a main road and illuminated with huge lights. Eventually I got the name of the road, and we drove back and forth until we spotted it. Luckily it was dark by then, and the big klieg lights made it easier to see. I've never seen a cab driver happier to be rid of me. I found Ritchie's trailer and handed over the props. Someone took the Booth Diary and drove it over to the filming location where they were shooting scenes with it.

I was about to grab another cab back to the train station and sleep on a bench until I could catch a train back to Connecticut, but Ritchie had other plans for me. There had been new script pages that day, and they needed new documents in the Book of Secrets. I'd need to research them, design, print, and age everything...*now*. Ritchie had a small desk in his prop trailer with a laptop and a printer, so I set to work. He asked if I needed anything from the drugstore in the strip mall. I gave him a list: Rit dye, iodine, rubbing alcohol, cotton balls, Q-tips, any paper that they had.

Ritchie then informed me that there would be even *more* documents needed—details TBD—and he wanted me on crew. I had no hotel booked, so he told the office to make arrangements. At around four in the morning, the crew wrapped at the location shoot

and headed back to base camp. I was told that the crew hotel was full, so I would get a room in the actors' hotel. I filled a bin with whatever supplies I might need for finishing the new documents, grabbed a spare typewriter from the prop trailer, and set out to find the van that was headed to the actors' hotel (the name of which no one seemed to know). Ritchie promised to call around 4:00 p.m. the next day with further instructions.

Soon the parking lot was filled with idling white vans, and people were yelling and dashing back and forth. I asked a few drivers where they were headed next, but none of them knew. Eventually I located the right driver, and I shared a ride to the hotel with a producer and several actors—Justin Bartha, Albert Hall, and Alicia Coppola. At first, they seemed a little suspicious of the quiet guy in the back with a large bin and a typewriter in his lap, but soon they settled in to talking about their favorite TV shows.

The next day I ordered coffee from room service to stain and age documents in the bathroom sink. As I was packing up and getting ready to go back to Bethesda base camp, Ritchie called and said there had been a crew move during the night, and there was a new base camp now, this time in downtown Washington, DC. He didn't have an address, but it was near the Library of Congress. I grabbed a cab, and repeated the search of the night before, driving back and forth and looking for a parking lot full of white tractor trailers. I was just relieved that it wasn't the same cabby. At base camp we loaded up with things we'd need on set, and a fleet of white vans took us all the few blocks to the library. It was after closing time when we arrived, and the crew had to string miles of cables and set up equipment, so the rest of us waited outside while curious onlookers gawked from the sidewalk and snapped photos of us standing around swilling coffee from craft services. Eventually the stars

swanned in and the rest of us were cleared to enter. I was worried that my go-bag full of sharp tools would cause problems at security. The assistant prop master had told me that earlier he had gone to scout a filming location that was in a secure facility and as the marines at the gate started searching his car, he suddenly remembered that the trunk was full of big, dangerous-looking prop guns. The guard at the library was friendly though, so I got a pass.

I spent that night and the next couple of nights on set. Because script rewrites were being done on the fly, much of the time was spent waiting for new script pages and new prop requests. One time they requested an envelope for a letter I had previously done, and wanted it to be rubber stamped TOP SECRET. I didn't have a TOP SECRET rubber stamp on me, but I had about five minutes to somehow produce this envelope in the middle of the night while the entire crew waited. Among the supplies in my bag, I had a larger document envelope that had TOP SECRET printed on it. The envelope itself was all wrong—too big and the wrong color. But it gave me an idea: with an X-Acto knife, I carefully cut out the letters stencil-style and cut the back off the envelope. I placed this newly created stencil over the correct envelope, got a red stamp pad, and, using my thumb, I dabbed red ink onto the stencil. The final result looked great. Ritchie took it without a word, handed it to the director, and the crew went back to work. Naturally, that envelope was never seen in the final movie.

Prop masters have a cart (called a taco cart, seriously!) full of all kinds of things they might need on set in an emergency. But there's only so much stuff the cart can carry, and my go-bag was a small messenger bag, so sometimes I would need to go back to base camp to print something out or use the computer or grab more paper. There was a convoy of the white vans

circling back and forth from the library to base camp all night, so I would go out to the street, flag a van, and repeat the process when I needed to go back.

My bag is full of tools and materials for work, but luckily I had jammed another shirt in there just in case. By the end of the week I had to buy new clothes and shoes. Since I had been living in this bubble for days, I actually had no idea where in Washington, DC, I was. The front desk told me I was in Georgetown and directed me to some clothing stores. The scenes they needed me for were done, and Ritchie told me that they now needed a map of Mount Vernon, so I was released to go home to work on that.

I was exhausted, but I had a huge amount of work to do on the map, so no rest for the wicked. The script called for Nic Cage to gain access to a fancy presidential event at Mount Vernon by swimming under the Potomac in scuba gear and wearing a backpack that held the map. They wanted the map to be framed, and it had to fit in this special waterproof tactical backpack. Because we always need multiple copies of any one prop, I had to locate three identical nineteenth-century frames that were the right size, which involved digging through the dusty corners of all the antique shops in the area.

The map went through several changes before they finally signed off on one. I worked all night to draw three copies of the approved map and frame them. Because time was tight I couldn't ship them overnight, so I arranged to meet a production assistant in New York. They drove up from Washington, DC, and I drove down from Connecticut. I proposed we meet in the lobby of Abrams bookstore. I went in and handed over the package, and we both turned and left. If the receptionist thought she was witnessing a drug deal, she didn't let on.

As I was driving back home, I was overcome with a huge feeling of relief. I felt like I had finally been

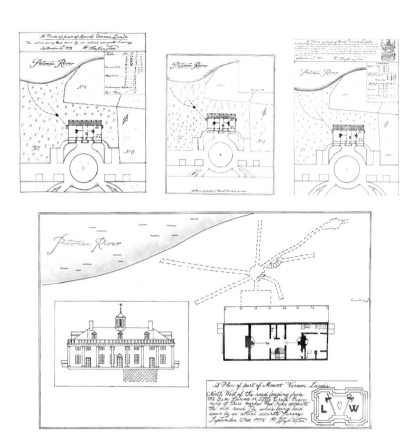

A few of the many versions of the map of Mount Vernon.

released, for a day or two at least. I called my kids, who I had hardly seen for three months, and asked them if they wanted to do anything. They did! And we went to the toy department in Target! As we were in the middle of this fun family jaunt, at about 6:00 p.m. my cell rang. It was Ritchie. He had gotten the maps. He said, "Ross, you're not going to fucking believe it, they want the map changed." Sometimes, when I lie awake at night, I can still hear his voice. They had ditched the scuba idea, or maybe not, I can't remember. Anyhow, now they wanted a larger map, without a frame. It had to be redone completely, and they needed to shoot the

scenes that very night. They were setting up the lights and cameras, and the actors were already in hair and makeup. As I stood in the Target toy section watching my kids happily root through the shelves I muttered curses, trying hard to keep it quiet. Ritchie pleaded with me to come to Mount Vernon (wherever that was) right now. I said that since cameras rolled at 9:30, I wouldn't be able to get there in time. Ritchie countered, "Rent a private plane. I'll pay you any amount of money to get here tonight." Clearly, he was as sleep deprived as I was.

At a point like this, my standard answer is usually, "Okay—I'll take care of it." The way you get repeat work from prop masters is by being a problem solver. No matter how knotty the problem, you figure out how to solve it, good and fast. Doing the impossible on an impossible deadline is just part of the job. But after several months of this, I was burnt. I knew there was no way I was up to this. So, thinking fast, I said, "Okay, I'll take care of it." Wait…what? Then I heard myself saying, "Ritchie, I can't make it myself, but I will get someone there by 9:30 who will take over for me, a total pro who can be on set tonight and produce the maps to the director's specs. Don't worry about it, it's all taken care of."

I had no idea who this person was that I was describing.

On the drive home from Target my mind raced, desperately attempting to come up with a plan. Part of me thought that if I just didn't answer the phone ever again and went into hiding, it'd all work out somehow. Who the hell could I call at eight o'clock at night and trick into doing this? It would have to be someone who was close enough to Washington, DC, to drive to Mount Vernon, and who was incredibly gullible. I called Brian Rea, who was then the *New York Times* Op-Ed page art director. I remembered that he had previously lived in Baltimore—that was near Washington, DC,

right? I had done Op-Ed illustrations before, and I knew that they're same-day turnaround. The art director calls in the late morning with the assignment, and the final art is due by late afternoon. So I figured that Op-Ed art directors would tend to hire illustrators who they knew could deliver good work fast. I also knew that Brian would probably still be at the office. Luckily, he picked up. Luckier still, he suggested someone.

I called this lucky person, illustrator John Kachik, and introduced myself. He said, "Ross, I love your work!" I replied, "Thanks! I love your work too!! So… anyway…" Then I went on to ask him if he would be interested in taking this on. Basically, what I was asking Kachik to do was to drop everything, pack a bunch of art supplies into his car, drive the hour or so to Mount Vernon, and spend the night frantically drawing and redrawing the same map. Not only would he do it, he was thrilled! He asked if he could bring a friend. I agreed, of course! Remembering Ritchie's offer of "any amount of money," I offered him a fairly hefty fee (one that the studio later balked at paying, but that's another story).

I spent the next couple of hours on the phone, letting Ritchie know the plan, helping the guy get access to the set, and making sure that he was settled in alright. He and his friend were *thrilled* at the prospect of working on a movie set and thanked me profusely. I told him to wait till the morning to thank me, and to call me when everything wrapped to let me know how it had gone. The next morning at 6:30 he called to say he was finally done. I asked him how it went. "It was fucking *horrible*!"

Welcome to my world…

The Book of Secrets came back to me a few times for repairs. I had to reattach the leather cord, which had originally been the bootlace of a hundred-year-old boot that I had found in the rafters of an old barn in Montana. There were also several new additions to the

book pages. I had to insert some hero pages of new handwritten text with clues to the location of the City of Gold.

By summer things had quieted down, and I seemed to be done. I called Ritchie. He was spending his day sitting in a warehouse reading newspapers while he waited for props to be shipped back from Europe, where they had been shooting. In late September I got another call; they were going to reshoot some scenes and needed new stuff. The movie was still set to open in mid-December, so it would be rushed.

There were some things on the reshoot list that I had already made, but there were many new things as well. Now they were going to shoot some of the inserts I had made for the Book of Secrets! And illustrations relaying the sixteenth-century tale of an expedition translator named Esteban discovering the City of Gold! And, for some reason, they were back to the idea of Nic Cage swimming under the Potomac with the map in a backpack.

Oh well, it didn't matter. I was well rested, and ready for more punishment.

NT2 RESHOOT WISH LIST Sept 26 2007

Set	Prop
Tavern	1865 Booth diary
Lab	2007 Booth diary
	2007 Booth diary on computer playback
Patrick house Dining room	Riley computer-
	1.incorrect words
	2.La Boulet
Patrick house Living room	Esteban book-
	1. more wood cuts Esteban Bens book sketches-
	1. Custer Battle at Big Horn w/caption[Custer's search for gold in the Black Hills ends in Tragedy]
	2. 3 scripted explorers- DeSoto, Pizzaro, Coronado
	3. Conquistadors
Patrick house Attic	Framed map of Mt. Vernon
Queens study	1.Malcolm Gilvary mark
	2.Four drawers
	3.1876 #'s under drawer
	4.Over sized drawers with bullet catch
Mercedes	1.Riley's computer
	2.Riley shooting pic. of plank on lap
	3. Ben shooting plank w/Abi. phone
	4. Traffic camera photo of plank
Bridge	Plank floating
Emily's office	1.New photo of plank from Merc.
	2.Ben writing on scratch pad
	3.Emily glasses
Ext. Whitehouse	Riley book-
	1.New Chapter 13 title page
	2.new photo's-
	A. Area 51 aerial shot
	B. Marilyn autopsy photo
	C. Zapruder still of motorcade
	D. Official Moon photo
	E. Stage Apollo photo
	F. Alien autopsy
Library of Congress	Book of Secrets-
	1. Queen Victoria letter
	2. Hand writing of various presidents
	3. Matching photo's to Riley's book
	4. JFK jr. under desk 8x10
	5. Period American plank photo
Mt. Rushmore	New inscription in Riley's book- " I never took the Book "
Cave	Mitch gets dagger from skeleton
Balance chamber	Mitch has dagger in belt
Ext. Sylvan Lake	Ben pulls lever inside rocks
Int. Buckingham Bathroom	Riley with Bluetooth and computer, devices???
Int. Buckingham lockup	1.Ben, Abigail with flower vase ?
	2.Buckingham Guard
Potomac river	Ben under water w/re-breather and suction device, under water backpack

Part of the director's "Reshoot Wish List."

Books

In filmmaking it is common for plots and personal characteristics to be revealed through the kinds of books that prop masters and set decorators use in a scene. Books can be necessary supporting characters and on a few occasions a book can play a starring role. When the camera fixates for more than a second on the spine or cover, it may say a great deal about how the film will be perceived. MacDonald has designed and manufactured dozens of books that are so central to a story line that if the verisimilitude is questionable chaos can ensue. There are moviegoers who spend an entire film searching for an anomalous typeface, a poorly designed binding, or paper stock that had not existed when the book was originally made. To get it right MacDonald delves into the history of objects. The ability to replicate the time period in which the book was created and duplicate the visceral exactitude is as essential as the actor mastering an accent or gesture. In fact, a flaw could easily hinder a performance.

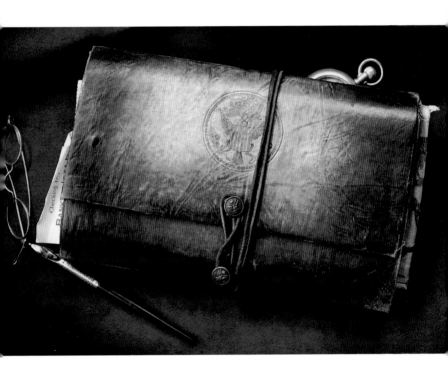

The screen-used Book of Secrets from
National Treasure: Book of Secrets.
The leather lace is from a hundred-year-
old boot I found in the rafters of a barn
in Montana.

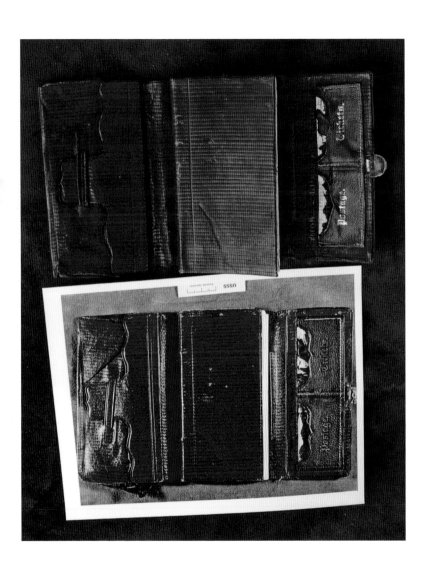

A prop replica of John Wilkes Booth's diary used in *National Treasure: Book of Secrets*, alongside a US Secret Service photo of the real diary.

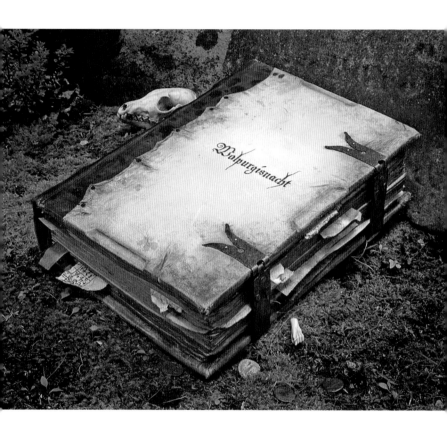

A large occult book, titled *Walpurgisnacht*
("Witches Night"), created for an amateur
film production. In the script description,
the book was bound in human skin and
had been buried with a witch. The binding
is based on a fifteenth-century missal, and
the clasp design is based on medieval
German door hinges.

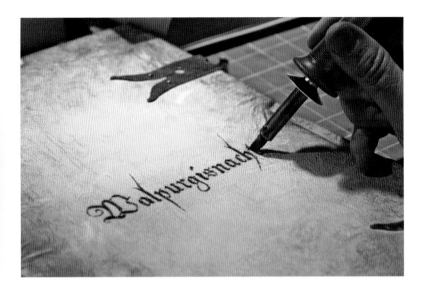

TOP:
Burning the lettering into the goatskin leather cover.

BOTTOM:
Forming the copper clasps for the book.

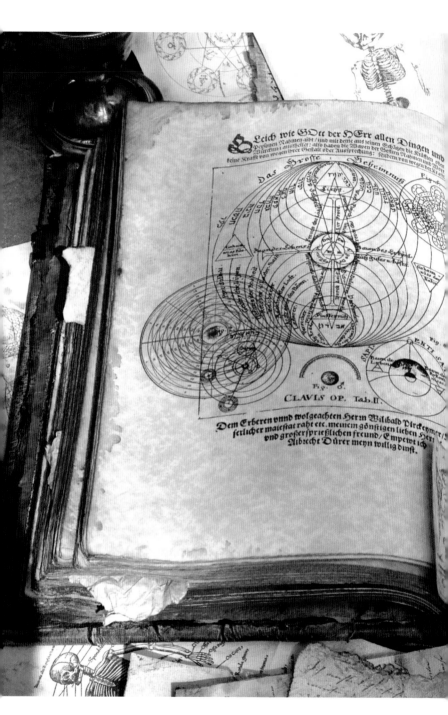

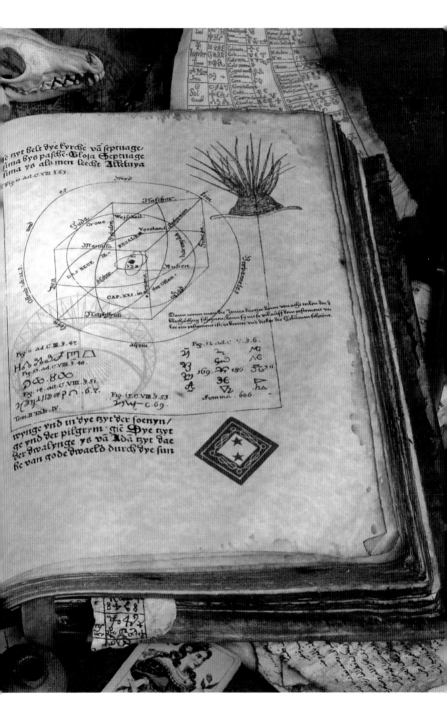

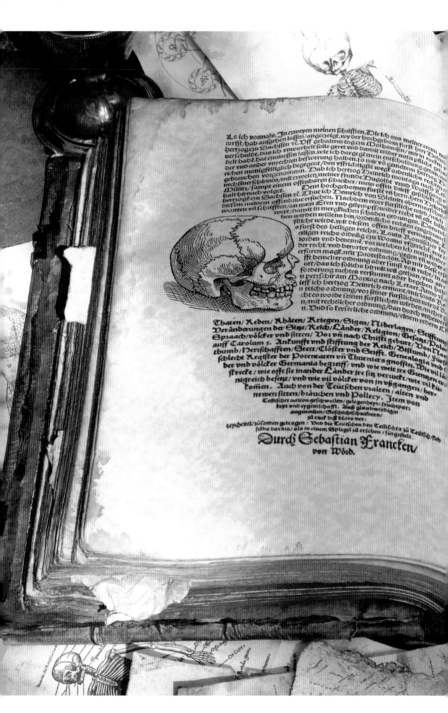

Thaten/ Reden/ Abdten/ Kriegen/ Sigen/ Siffen/
Veränderungen der Stne/ Reich/ Länder/ Religion/ Siffen/
Spraach/ völcker vnd sitten/ Vor vn̄ nach Thristi geburt/ Von Pol.
auff Carolum 5. Ankunfft vnd stifftung der Reich/ Bißtumb/ Fün.
thumb/ Herbschafften/ Stett/ Clöster vnd Stifft. Genealogia/ für
schlecht Register der Potentaten vn̄ Thurnier s gnossen. Wie vil/
der vnd völcker Germania begreifft/ vnd wie weit jre Gräntzen er.
strecke/ wie offt sie in ander Länder jre sitz verruckt/ wie vil kü.
nigreich beseßt/ vnd wie vil völcker von jn vßgangen. Auch von der Türcken vralten/ alten vnd
newen sitten/ bräuchen vnd Pollecy. Item von
Teütscher nation geschweigen/ gelegenheyt/ fruchtparkeyt vnd eygenschafft. Auß glaubwirdigen
angenomen/ Geschichtschreibern/
zů rauß diß blatz weiß/

zeychenet/ zůsamen getragen/ Vnd die Teütschen den Teütschen zů Teütsch/ sich
selbs darhin/ als in einem Spiegel zů ersehen/ fürgestelt.

Durch Sebastian Francken
von Wörd.

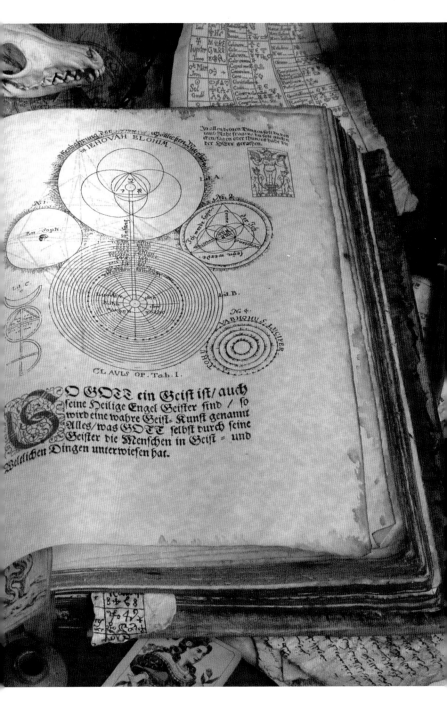

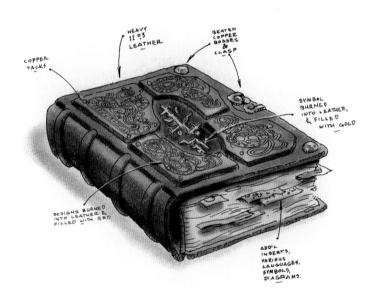

Labels on the illustration:

HEAVY 11 OZ LEATHER

BEATEN COPPER BOSSES & CLASP

COPPER TACKS

SYMBOL BURNED INTO LEATHER, & FILLED WITH GOLD

DESIGNS BURNED INTO LEATHER & FILLED WITH RED

ADD'L INSERTS, VARIOUS LANGUAGES, SYMBOLS, DIAGRAMS.

PREVIOUS:
Interior spreads from *Walpurgisnacht*. The art on the pages is collaged together from diagrams from a sixteenth-century book on theosophy, biological drawings, arcane symbols, and bits of medieval text. There were also many inserts—diagrams, engravings, and scraps of paper with writing in many languages, both lost and otherwise.

ABOVE:
Sketch for a book of spells for *The Christmas Chronicles: Part 2* (2020).

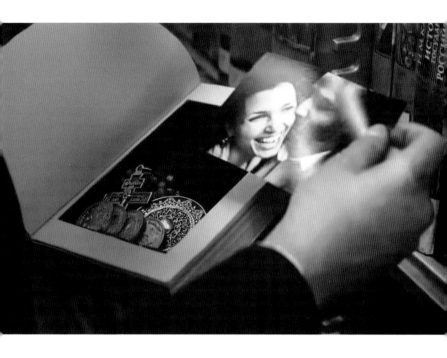

Scene from *John Wick: Chapter 3* (2019).
Keanu Reeves's character pulls a book
from the shelves of the New York Public
Library, and inside is a secret compart-
ment with coins and various mementos.
In the original script, there was also a gun
in the compartment, but the director
decided to have Reeves's character kill an
assailant with the book itself instead.

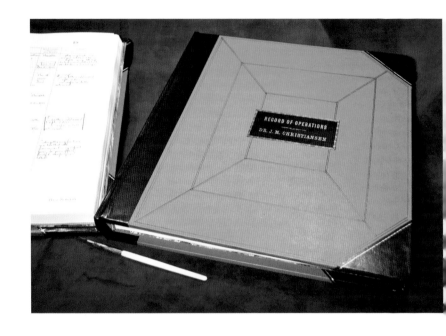

One of many large leather-bound books
for the Cinemax series *The Knick* (2014–15),
which is set in a New York City hospital
at the turn of the twentieth century.

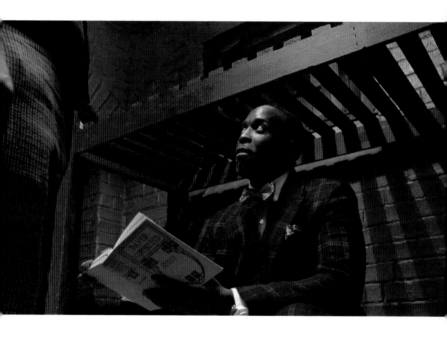

Michael Kenneth Williams as his character Chalky White in a scene from the HBO series *Boardwalk Empire*. In this scene he's in a jail cell, and another prisoner grabs his book and throws it against the wall, leaving Chalky holding a single torn-out page with an illustration on it. I replaced the binding of three copies of an early twentieth-century edition of the book so that it looked new. The binding was reinforced to withstand multiple takes of throwing it at the wall. The illustration page was pre-torn and attached to a small tab bound into the binding. The prop master needed three copies so he could quickly reset between takes, reattaching the torn page.

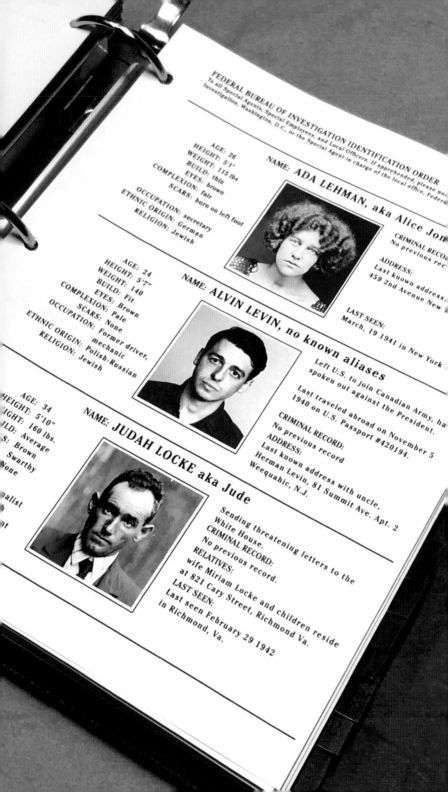

FEDERAL BUREAU OF INVESTIGATION IDENTIFICATION ORDER
To all Special Agents, Special Employees, and Local Officers. If apprehended, please not
Investigation, Washington, D.C., or the Special Agent in charge of the local office, Federa

NAME: ADA LEHMAN, aka Alice Jon

AGE: 26
HEIGHT: 5'1"
WEIGHT: 115 lbs
BUILD: thin
EYES: brown
COMPLEXION: fair
SCARS: burn on left foot
OCCUPATION: secretary
ETHNIC ORIGIN: German
RELIGION: Jewish

CRIMINAL RECO
No previous rec

ADDRESS:
Last known address:
459 2nd Avenue New

LAST SEEN:
March, 19 1941 in New York

NAME: ALVIN LEVIN, no known aliases

AGE: 24
HEIGHT: 5'7"
WEIGHT: 140
BUILD: Fit
EYES: Brown
COMPLEXION: Pale
SCARS: None
OCCUPATION: Former driver,
ETHNIC ORIGIN: mechanic
RELIGION: Polish-Russian

Left U.S. to join Canadian Army, ha
spoken out against the President.

Last traveled abroad on November 5
1940 on U.S. Passport #420194.

CRIMINAL RECORD:
No previous record
ADDRESS:
Last known address with uncle,
Herman Levin, 81 Summit Ave. Apt. 2
Weequahic, N.J.

NAME: JUDAH LOCKE aka Jude

AGE: 34
HEIGHT: 5'10"
WEIGHT: 160 lbs.
BUILD: Average
EYES: Brown
COMPLEXION: Swarthy
SCARS: None

ETHNIC ORIGIN: ...alist
RELIGION: ...t

Sending threatening letters to the
White House.
CRIMINAL RECORD:
No previous record.
RELATIVES:
wife Miriam Locke and children reside
at 821 Cary Street, Richmond Va.
LAST SEEN:
Last seen February 29 1942
in Richmond, Va.

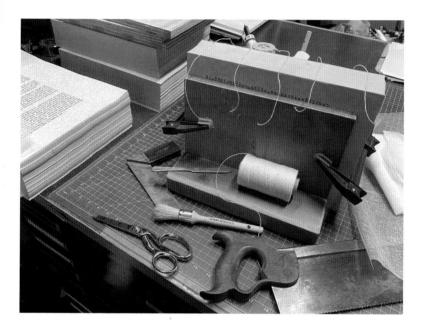

OPPOSITE:
An FBI binder of people wanted for questioning, from the HBO series *The Plot Against America*. This is the "hero" page, with Anthony Boyle's character Alvin Levin on it. There were about a dozen additional pages made for this binder, with public domain mug shots and copy written for each person—names, aliases, descriptions, crimes, etc. Many times, the work of generating copy for these types of documents takes longer than making the document itself.

ABOVE:
Binding the book blocks for a series of large prop books.

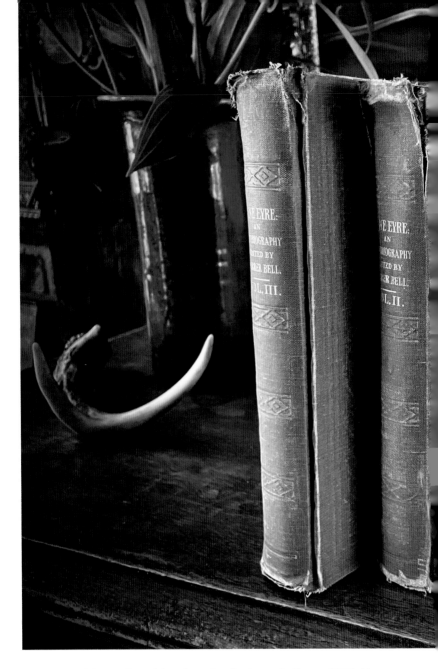

A replica of the 1847 first edition of *Jane Eyre* for the movie *Sharper* (2022). After I shared source images with the director, I was grateful that they chose to go with an exact replica of the real thing—even though the books were small, quite plain, and in three volumes—rather than requesting a larger, ornate leather bound book.

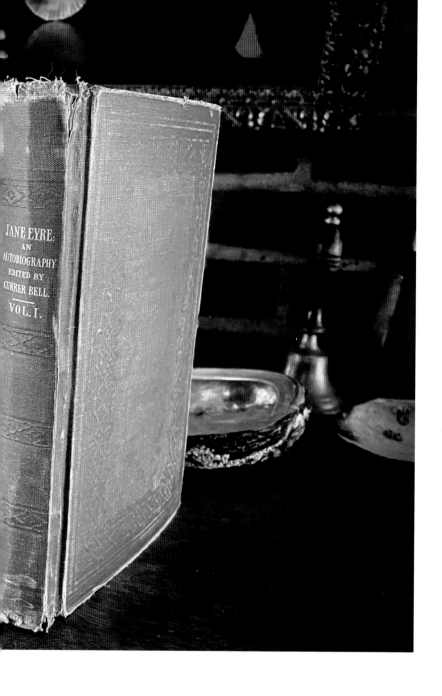

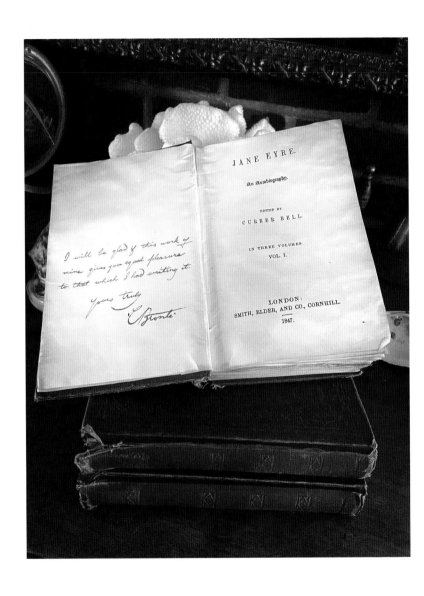

The title page of the first volume of the
Jane Eyre replica set, featuring my attempt
at Charlotte Brontë's handwriting.

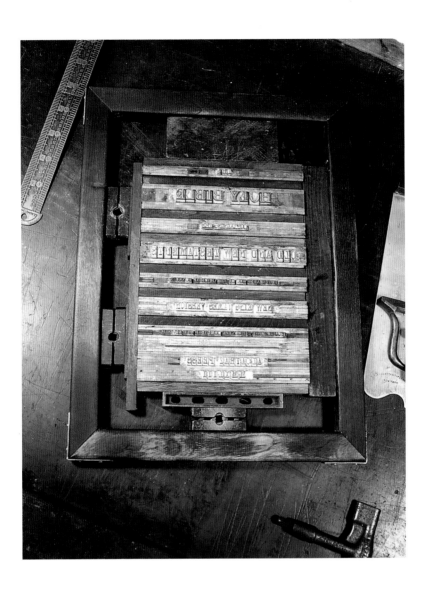

Hand-set metal type, locked up in
a handmade wooden frame, for the
Bible printing scenes in *The Book of Eli*
(2010). The type was cast from antique
nineteenth-century matrices, or molds
for the letterforms.

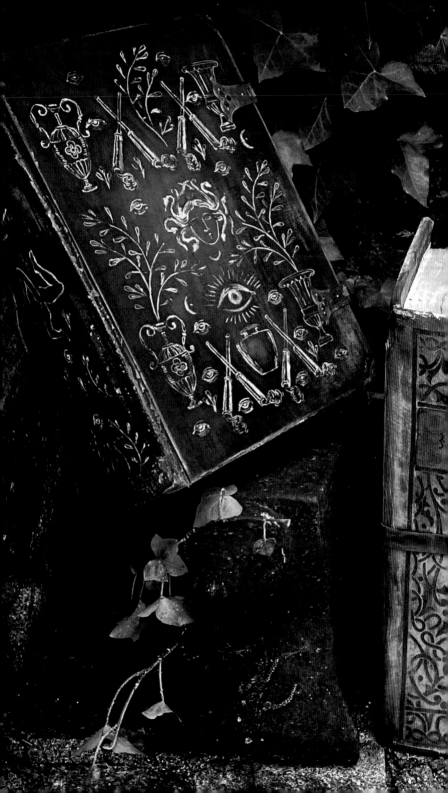

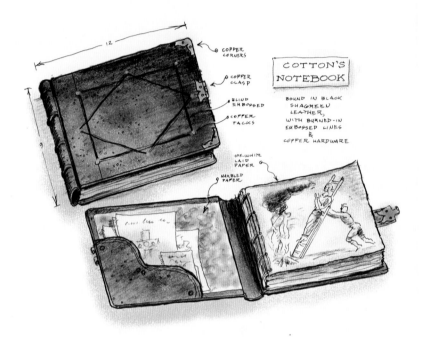

COPPER
CORNERS

COPPER
CLASP

BLIND
EMBOSSED

COPPER
TACKS

COTTON'S
NOTEBOOK

BOUND IN BLACK
SHAGREEN
LEATHER,
WITH BURNED-IN
EMBOSSED LINES
&
COPPER HARDWARE

OAK-WHITE
LAID
PAPER

MARBLED
PAPER

12

9

PREVIOUS:
Leather bound books for *Shazam! Fury
of the Gods* (2023), just before they were
shipped to the set. Each book weighed
thirty pounds.

ABOVE:
Sketch for Cotton Mather's notebook,
for the series *Salem.*

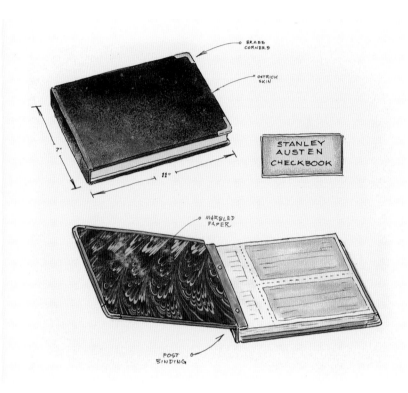

Sketch for a character's checkbook
for the AMC series *Dietland* (2018).

Documents

An official document as common as a passport, birth certificate, letterhead, business card, evidence tag, file folder, or ledger page will usually get a millisecond of screen time, but accuracy is essential—even the smallest error can undo the illusion that the filmmaker is attempting to impress on the audience. Therefore, MacDonald balances his deep research of materials with the limited time allowed to produce the perfect prop. Although the audience may never see even a fragment of the document used by the actor, a prop cannot be imagined. The reality of everything on the set, no matter how ultimately insignificant, can make the difference between a convincing portrayal and an unbelievable fake. The actor has to feel as certain about the truth of a prop as the audience lest the magic will fail.

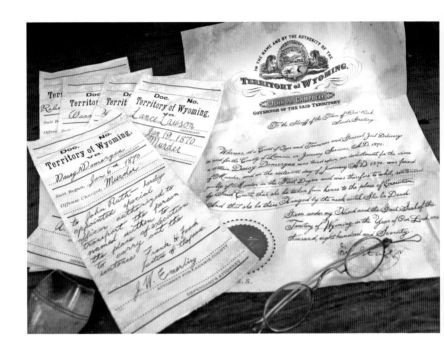

Warrants for the arrest of Daisy Domergue and
other characters from *The Hateful Eight*.

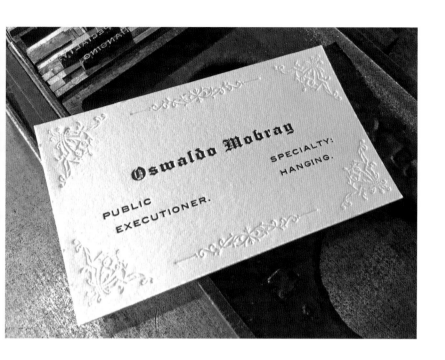

Calling card for *The Hateful Eight*.

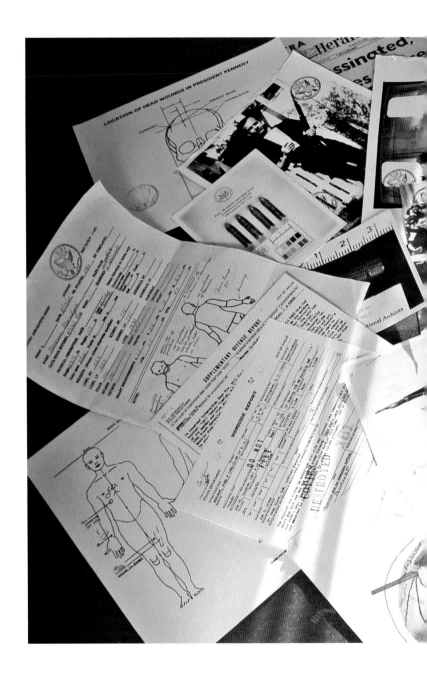

Some of the JFK documents from
the Book of Secrets.

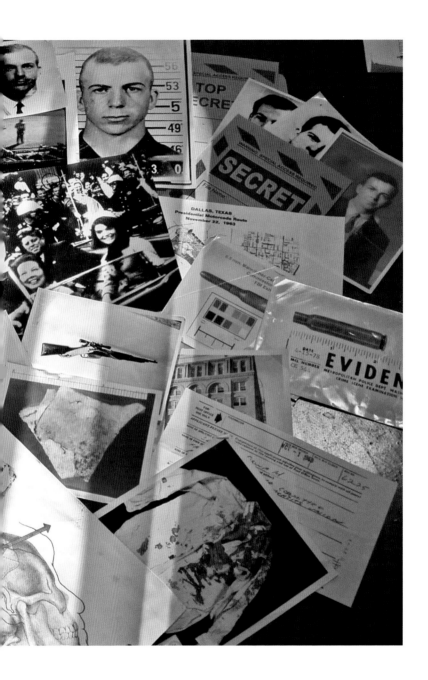

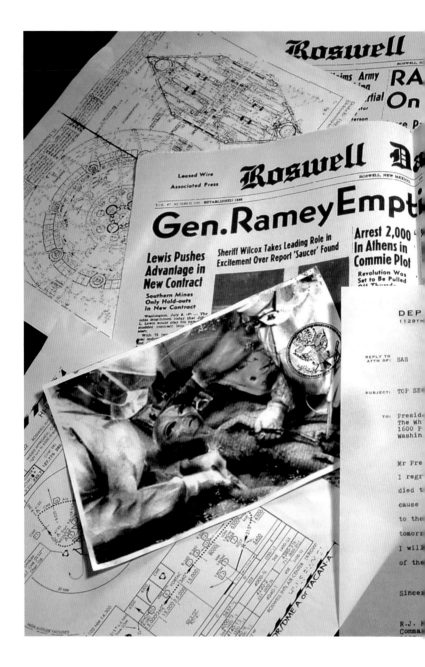

Additional Book of Secrets documents
related to Area 51.

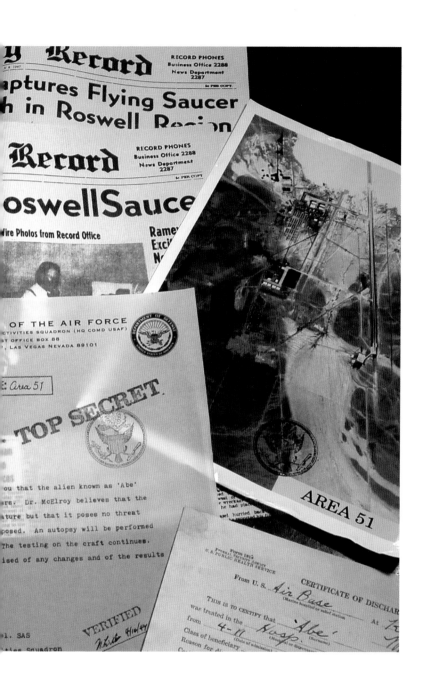

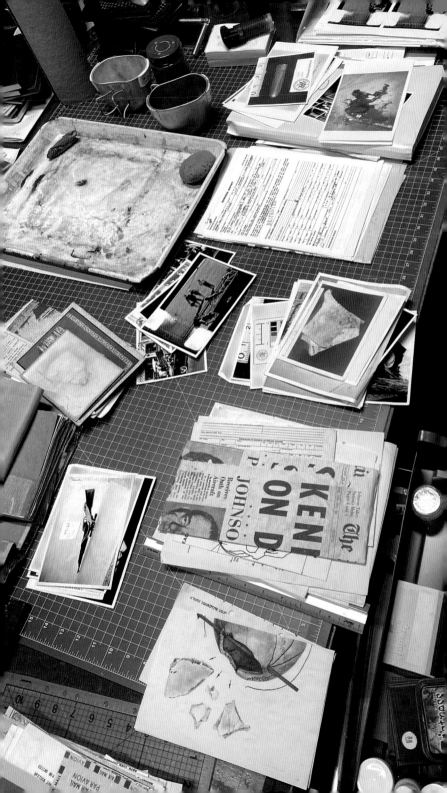

OPPOSITE:
Aging the Book of Secrets documents.

ABOVE:
"Ancient" paper and papyrus scrolls
for *Shazam! Fury of the Gods*.

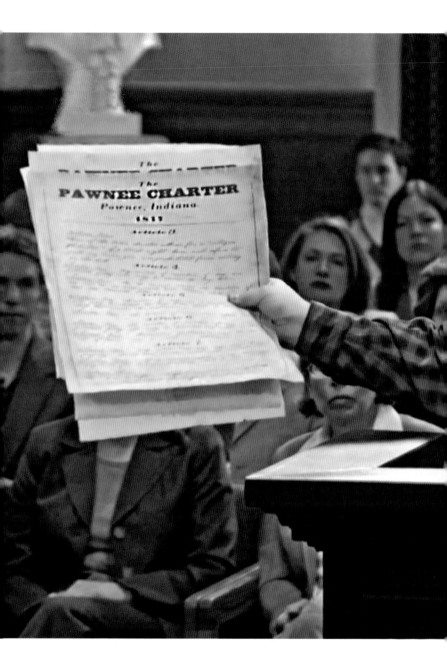

Patton Oswalt holding a copy of the Pawnee
town charter on *Parks and Recreation*.

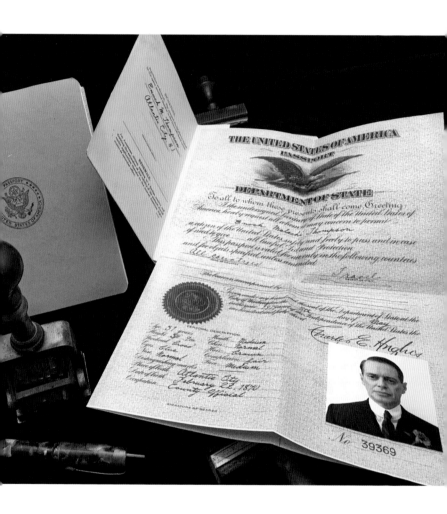

A replica 1920 passport for Steve
Buscemi's character Nucky Thompson
on *Boardwalk Empire*.

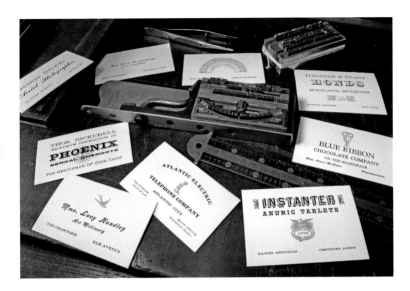

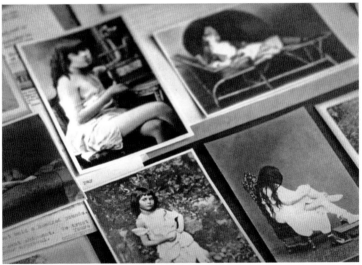

TOP:
Business cards for *Boardwalk Empire*, hand-set and printed letterpress from nineteenth-century type and ornaments.

BOTTOM:
Photos of young girls, some real, some created in Photoshop, for *Boardwalk Empire*.

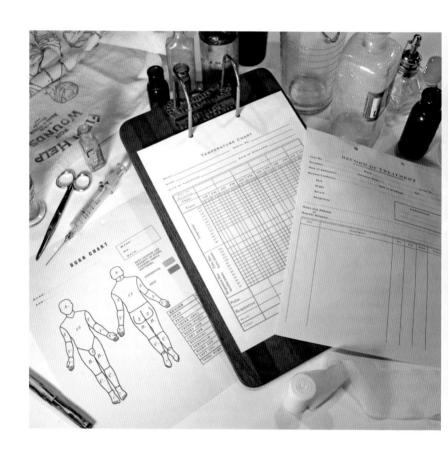

Medical forms for a hospital
scene in *Boardwalk Empire*.

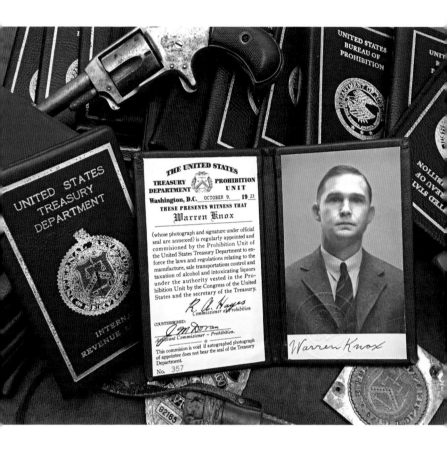

Some of the agent ID folders
for *Boardwalk Empire*.

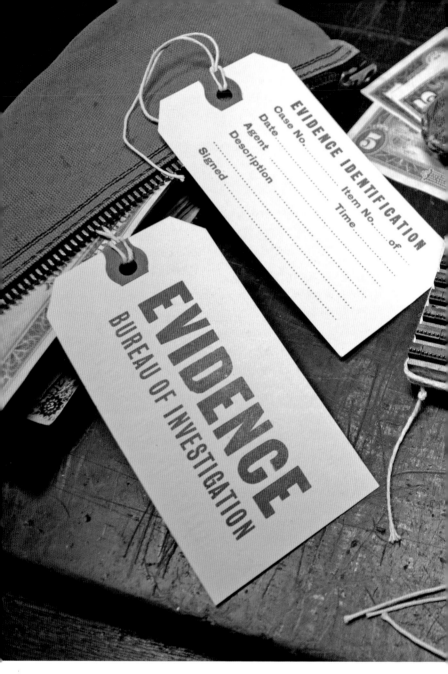

Evidence tags for *Boardwalk Empire*, and the type they were printed from. The wood type font used for the word "Evidence" was missing a capital D, so I had to carve one.

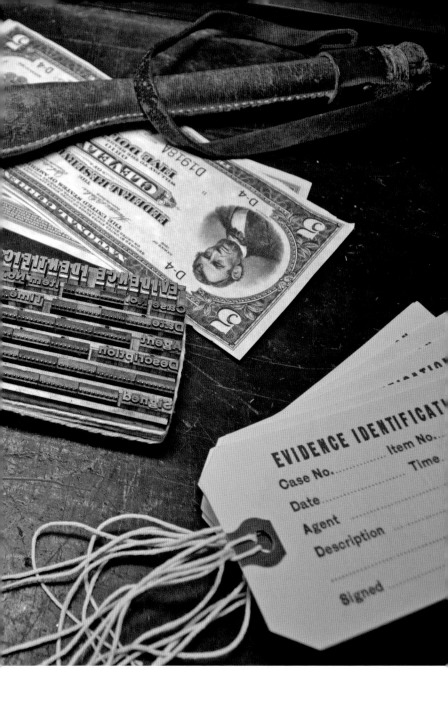

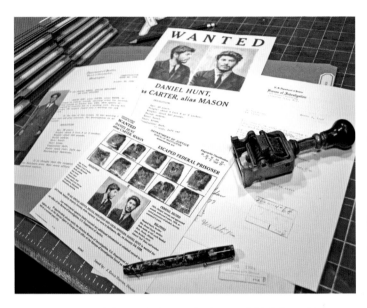

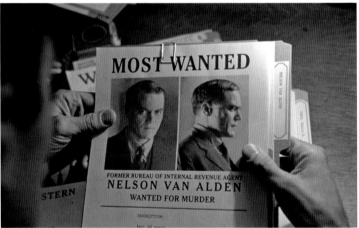

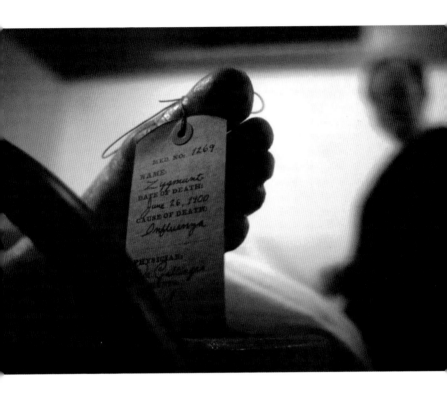

Corpse toe tag for the series *The Knick*,
which is set in a New York City hospital at
the turn of the twentieth century.

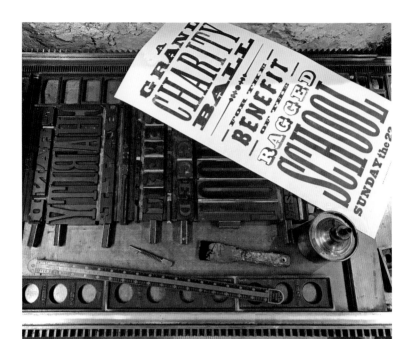

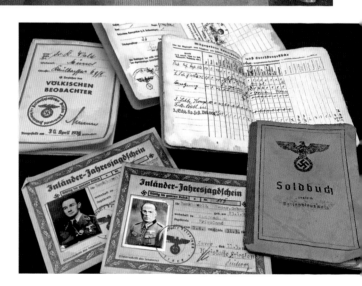

TOP:
Poster for *Come Away* (2020). Hand-set and printed from nineteenth-century wood type.

BOTTOM:
Nazi documents for *This Must Be the Place* (2011). To avoid legal issues, I created dummy likenesses for the Nazi officers.

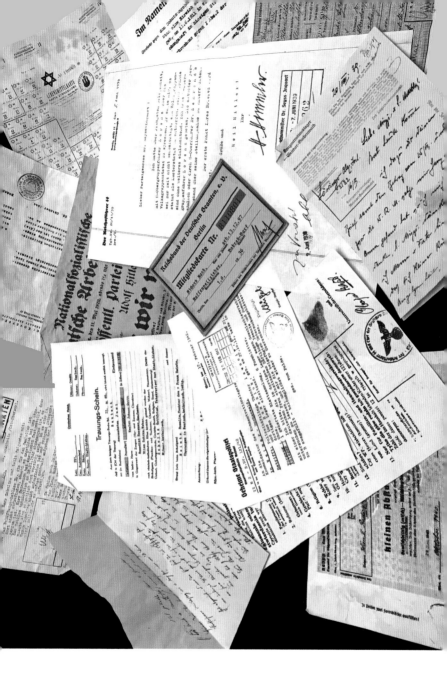

More Nazi paperwork for *This Must Be the Place*, for a scene in the office of a present-day Nazi hunter.

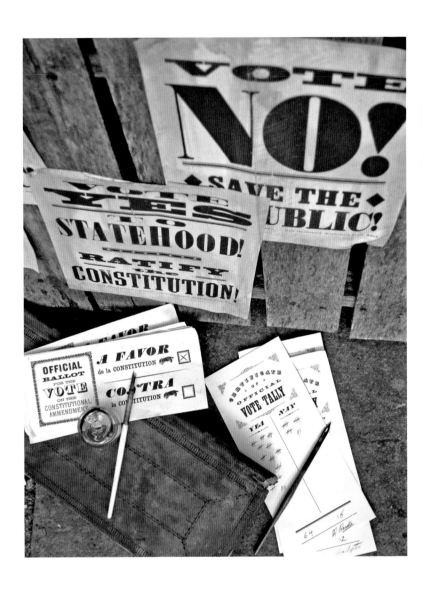

Ballots, dodgers, and vote tally sheets for
The Legend of Zorro. Printed letterpress from
nineteenth-century wood type and metal type.

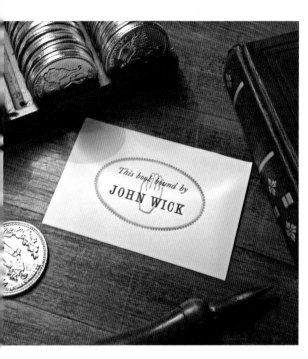

TOP:
Calling card for Keanu Reeves's character in *John Wick*.

BOTTOM:
Large deed for *The Legend of Zorro*.

Illustrations

MacDonald entered the world of prop design owing to his drawing skill. His earliest commercial work was pictorial and representational; the props came later. But his drawings are also often used as props in their own right; the Hitler postage stamps that he rendered and printed are an example of wedding these skills into a single entity. His keen ability to render ideas is a double whammy for a prop master. Although MacDonald's forte is twenties- and thirties-era comics and illustration styles, he is adept at mimicry of other periods and different genres. His work runs the gamut from eighteenth-century woodblock and ink book illustration to Victorian-era decorative painting for labels. He is an artist-chameleon whose illustrations subtly blend into scenes rather than steal the spotlight.

Final artwork for the Red Apple tobacco tin for *The Hateful Eight*. Watercolor and digital.

OPPOSITE, TOP:
One of the Hitler stamp "engravings," drawn with black Prismacolor.

OPPOSITE, BOTTOM:
Hitler stamps for *The Plot Against America*. These were for a dream sequence where the faces on the 1940 Famous Americans stamps were replaced by images of Hitler. All existing Nazi stamps show Hitler's face in profile, so I had to draw ten full-frontal versions.

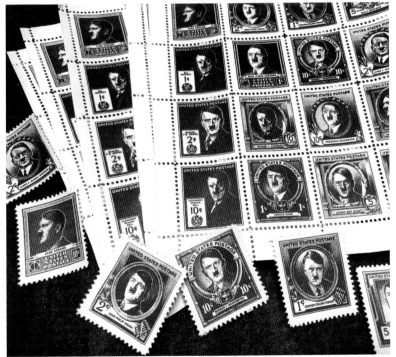

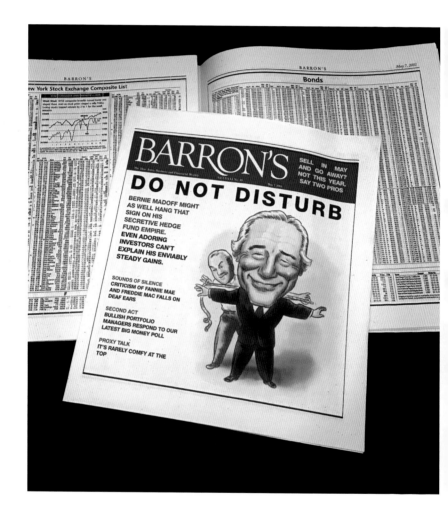

Replica of *Barron's* magazine, with an
illustration of Robert De Niro as Bernie
Madoff. Watercolor and colored pencil.

De Niro as Madoff in *The Wizard of Lies*,
with a copy of *Barron's* featuring him on
the cover.

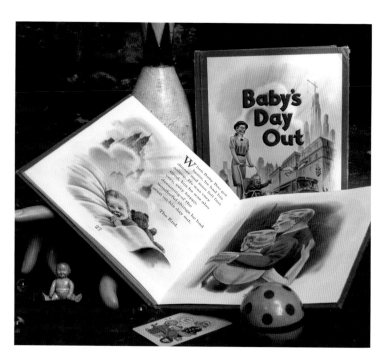

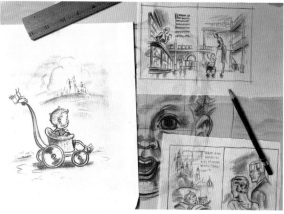

TOP:
The baby's book from *Baby's Day Out*.
The book appears throughout the film, and
many of the illustrations run full screen.

BOTTOM:
Original sketches for the *Baby's Day
Out* book.

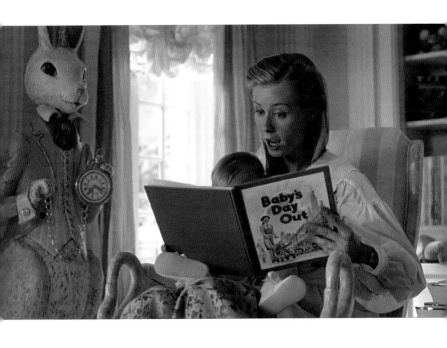

ABOVE:
Cynthia Nixon as a nanny reading
the book to Baby Bink.

OVERLEAF:
Pen and ink illustrations for
a prop coloring book for a scene
in *Boardwalk Empire*.

93

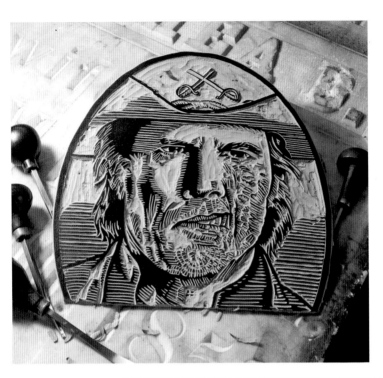

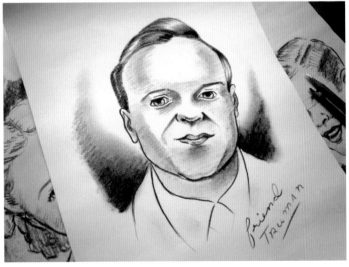

TOP:
Linocut for a wanted poster illustration of Josh Brolin as his character in *Jonah Hex* (2010).

BOTTOM:
Pencil drawing of Toby Jones as Truman Capote in *Infamous* (2006).

Jones as Capote holding another drawing
by Daniel Craig's character, Perry Smith. Smith,
one of the Clutter family killers, was an amateur
artist who reportedly designed his own tattoos,
by which this image was inspired.

For *National Treasure: Book of Secrets*, a faux copy of Cabeza de Vaca's book *Naufragios*, with an illustration depicting one of the Narváez expedition ships wrecking on the coast of Galveston Island.

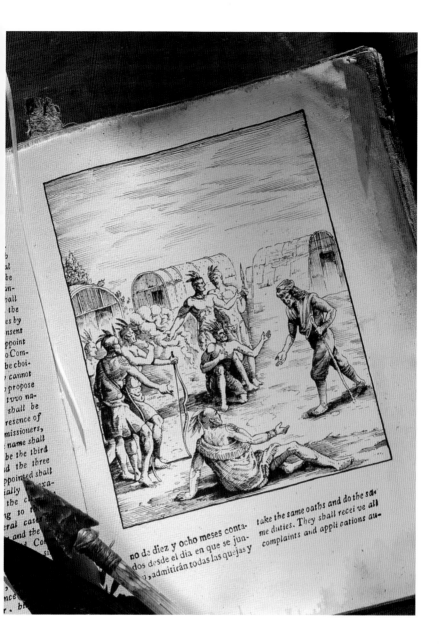

Another *Naufragios* illustration, showing
the expedition translator Esteban
approaching Native American warriors.

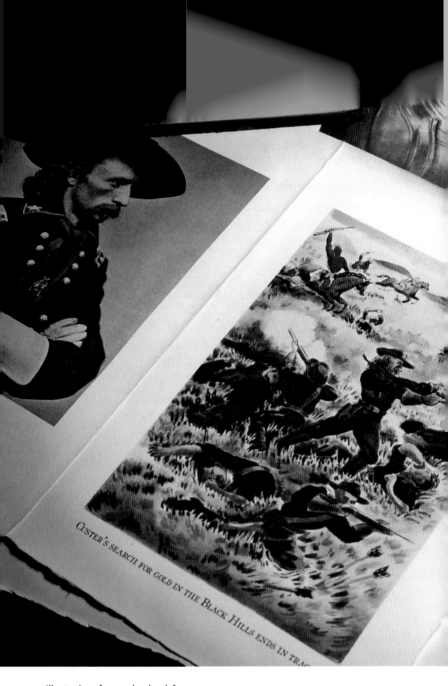

CUSTER'S SEARCH FOR GOLD IN THE BLACK HILLS ENDS IN TRA

Illustrations for another book for
a scene in *National Treasure: Book of
Secrets*, used to explain the "history"
of the search for the City of Gold.

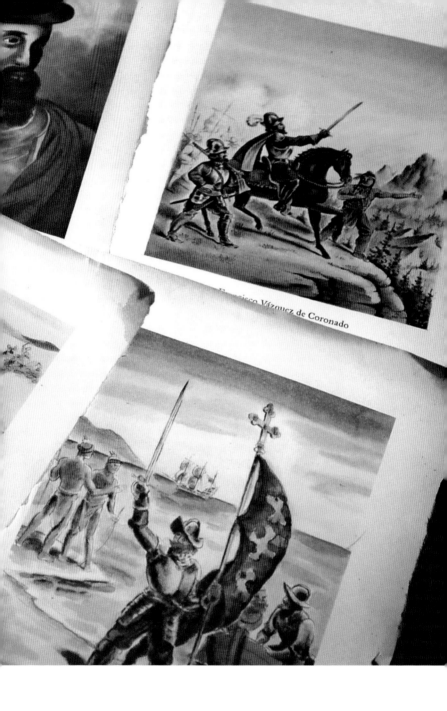

Francisco Vázquez de Coronado

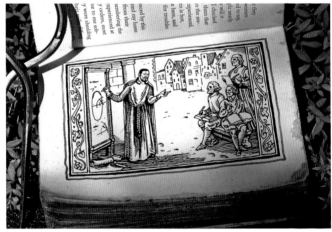

TOP:
For the series *Salem* (2014–16), an illustration from Cotton Mather's sketchbook depicting a witch-controlling rig.

BOTTOM:
In the movie *King of California*, Michael Douglas's character Charlie discovers a book that tells of a gold treasure hidden in California by early Spanish monks. This illustration becomes animated, and Charlie walks into the scene and discourses with the monk.

Charlie's daughter, played by Evan Rachel
Wood, looks at another illustration,
showing one of the clues Charlie uses
to find the buried gold.

TOP:
In a scene from *The Alamo* (2004), Patrick Wilson's character William Travis shows a sketch of his own design for his uniform.

BOTTOM:
Page mock-up for a book prop for *Shazam! Fury of the Gods*. The illustrations are of characters played by Helen Mirren, Lucy Liu, and Rachel Zegler.

Sketch for a book illustration for *Shazam!
Fury of the Gods.*

Final illustration in progress. Pen and ink.

Packaging

It is fairly easy for a prop master to find original examples of vintage package design—tobacco pouches, matches, foodstuffs, and sundries— at flea markets and auctions. But invariably these objects will be ravaged by age and the elements, with torn edges and bits of mold. Even if a package is only on-screen for the usual split second, particularly on a period stage set, the scene should not evoke the interior of an antique shop. So, MacDonald spends considerable time researching what an old product might look like the moment it came off the shelf. Boxes and tins must be entirely believable lest the aura of the prop fail to do its small but important job.

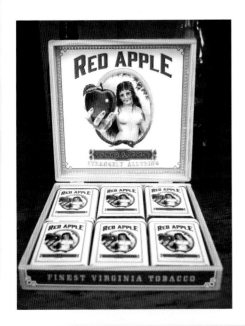

OPPOSITE:
Red Apple tobacco tin for *The Hateful Eight*.

TOP:
Red Apple counter display box. This prop wasn't requested, but since the movie mostly takes place in a nineteenth-century store, where tobacco products were often displayed on the counter, I decided

to make it just in case. In the film, it appears on the shelves.

BOTTOM:
Damián Bichir, as Bob, enjoys some Red Apple tobacco. The Red Apple brand of tobacco and cigarettes appears in all of Quentin Tarantino's movies after *Pulp Fiction* (1994).

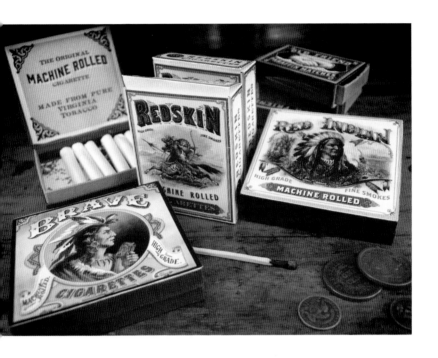

OPPOSITE, TOP:
For *The Hateful Eight*, a pen and ink drawing of the Old Friends matches label.

OPPOSITE, BOTTOM:
Completed matchbook prop for *The Hateful Eight*. The box is handmade from thin basswood and cardboard, in the period style. Although some props were specifically mentioned in the script, many, like the matches, were made in anticipation of them being needed, even though they weren't requested.

ABOVE:
Director Quentin Tarantino requested some Native American–themed cigarette packaging. With no other specifics, prop master Don Miloyevich and I were left to come up with some Tarantino-like brand names. These were all real nineteenth-century tobacco brand names, but the label designs are original—comprised of images from old cigar boxes with new hand lettering. The boxes were assembled by hand.

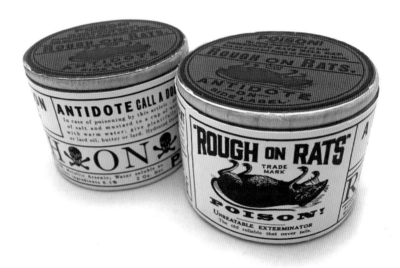

A replica of a wooden container of Rough
on Rats poison, for *The Hateful Eight*.

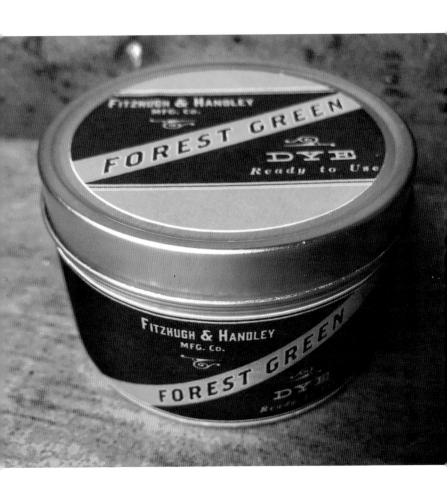

A tin of fabric dye for *Come Away*.

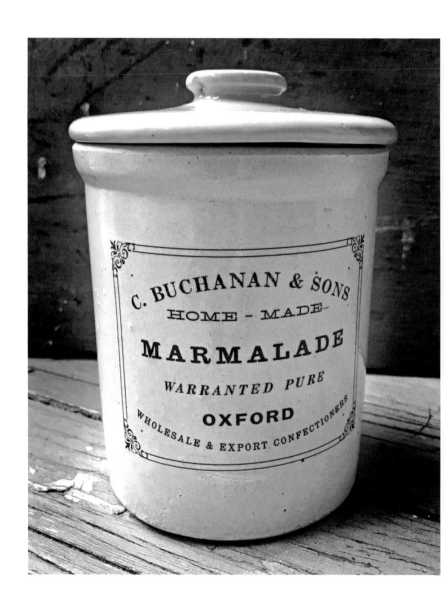

A real nineteenth-century crock with a replica label applied, for *Come Away*.

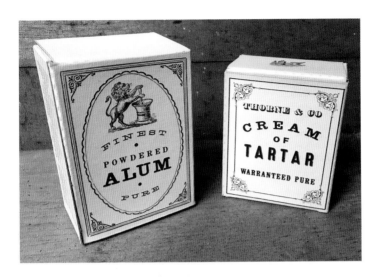

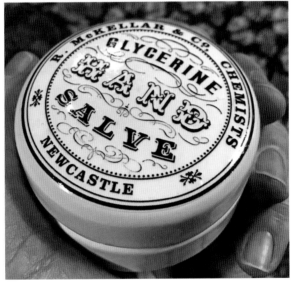

TOP:
More kitchen packaging for *Come Away.*

BOTTOM:
A ceramic crock of hand salve, in the late
nineteenth-century English style, for *Come
Away.* The label features hand lettering.

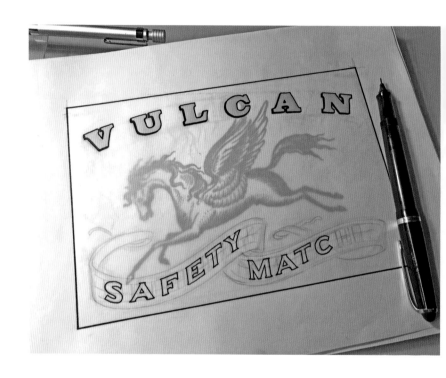

Hand lettering in process for
matchbox label art.

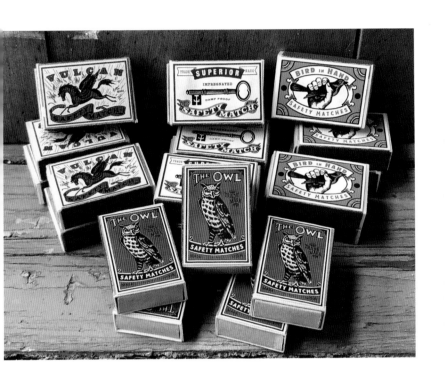

Matchbox label designs for the HBO
series *The Gilded Age* (2022), set in 1880s
New York City.

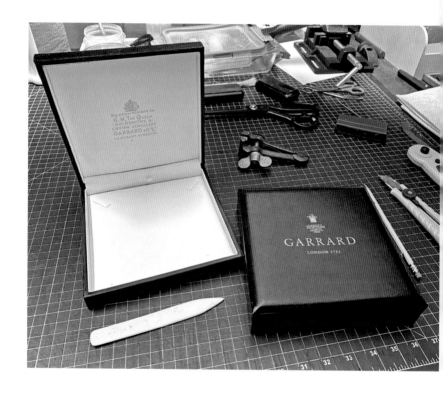

OPPOSITE:
Cigarette and matchbox packaging for *The Knick*.

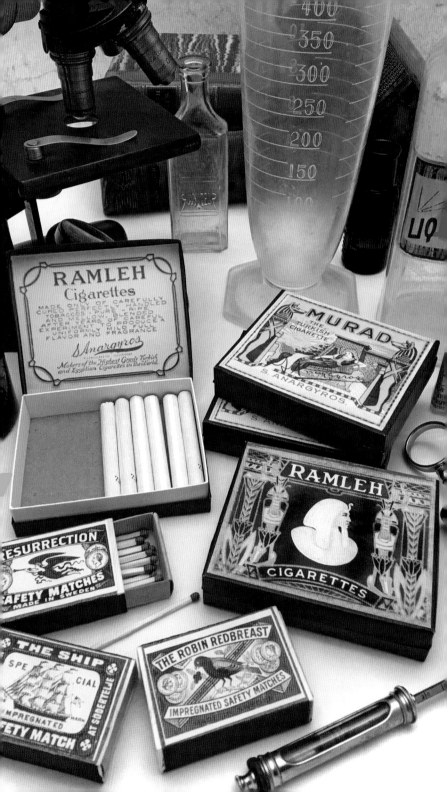

Periodicals

For film, newspapers are among the most expository props in a graphic designer's tool kit. They are used to indicate time and place and serve as captioning devices. The replica of the banner headline on the front page of the *Pittsburgh Post-Gazette* underscores the story line in *The Plot Against America*, informing the audience that an airplane piloted by the film's fictional president of the United States, Charles Lindbergh, has gone missing. Periodicals are tricky: paper and ink must have the correct patina for the era but cannot look deliberately antique. Making facsimiles is one of the hardest balancing acts that MacDonald has mastered.

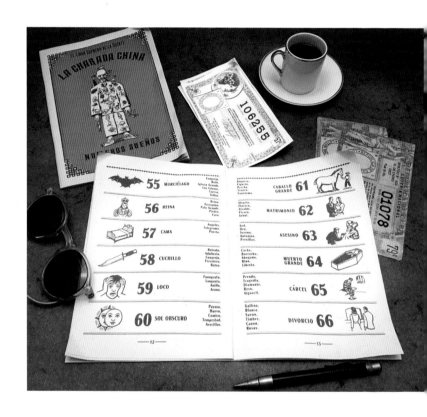

For *Boardwalk Empire*, some Cuban lottery tickets and a dream book used for choosing lottery numbers. I drew one hundred new spot illustrations for the book.

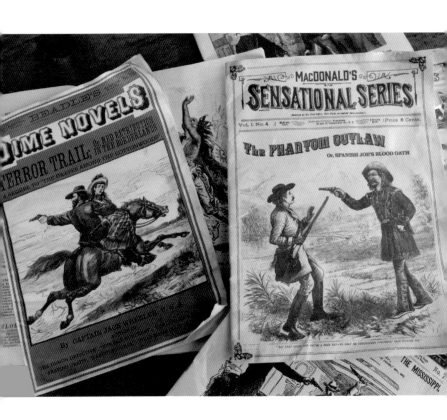

Dime novels for *The Hateful Eight*.

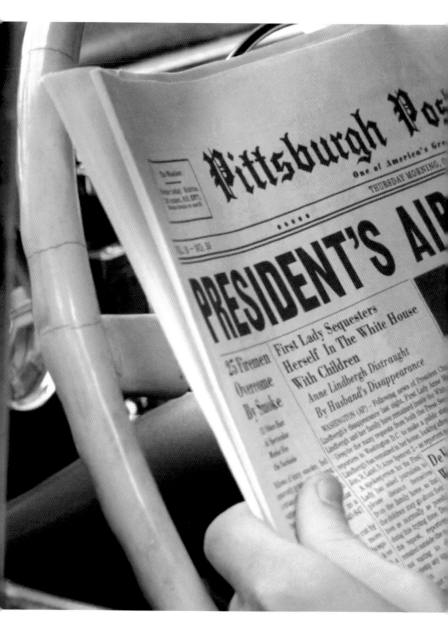

A scene from *The Plot Against America*. As viewers, we discover a lot of the momentous events the characters are living through the same way they do—by reading about them in the papers.

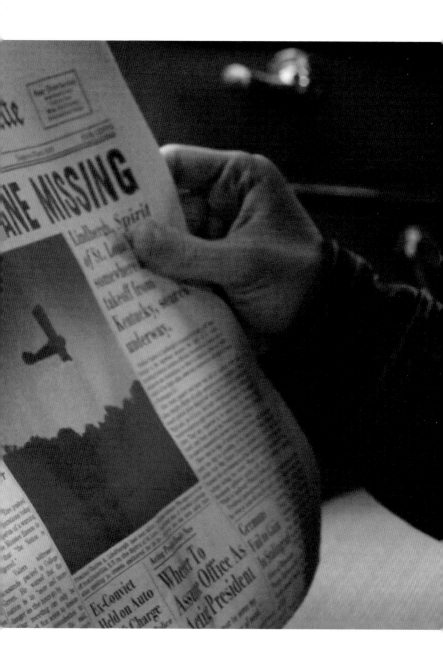

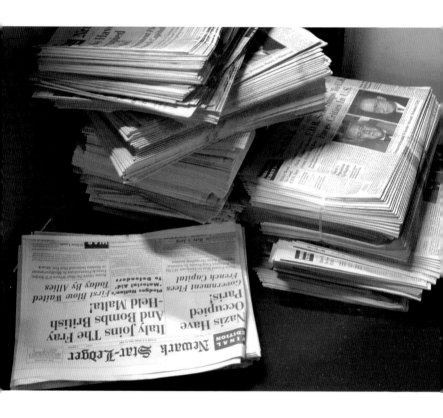

With help from designers James Reyman and Jack Tom, I designed and printed over thirty magazines and newspapers for *The Plot Against America*. Although you can find some images of old newspapers online, to create truly believable replicas it's necessary to track down actual copies from the period, which is not always easy given their ephemeral nature.

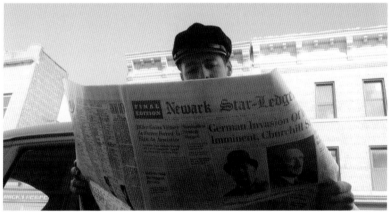

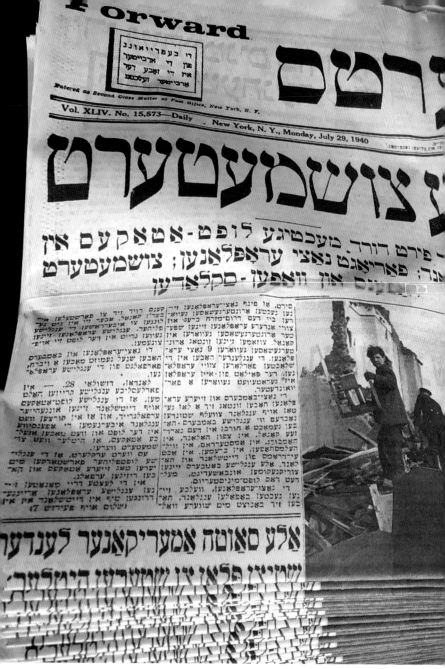

The venerable Yiddish-language newspaper
the *Jewish Daily Forward* makes a couple of
appearances in the show.

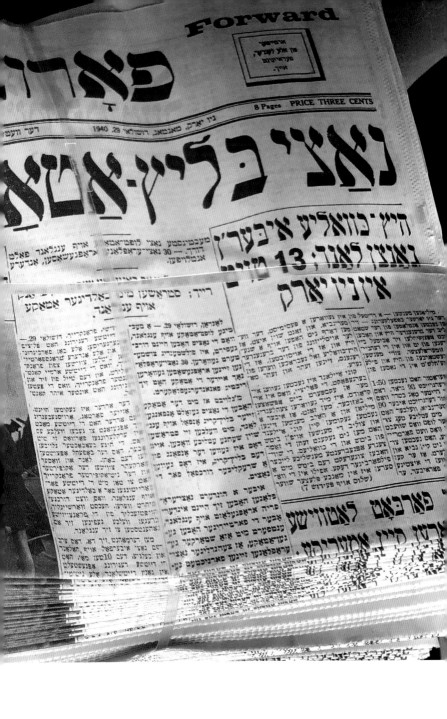

Morgan Spector as Herman Levin reads
a copy of *PM* (short for *Picture Magazine*)
in *The Plot Against America*.

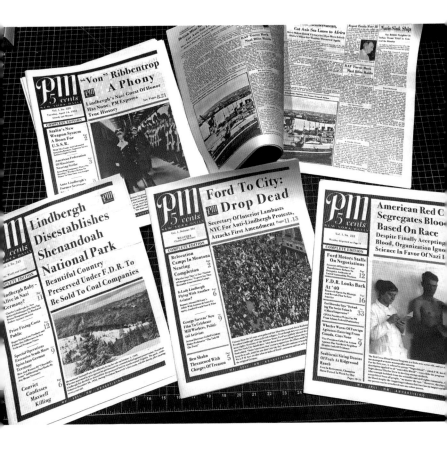

PM was the Life magazine of the Left in the 1940s. I had some real period copies that I used to replicate these prop versions.

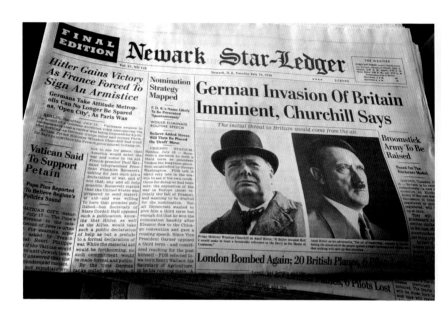

All of the copy in the newspapers for *The Plot Against America* was accurate—either pulled from real period newspaper stories or written by the show's writers.

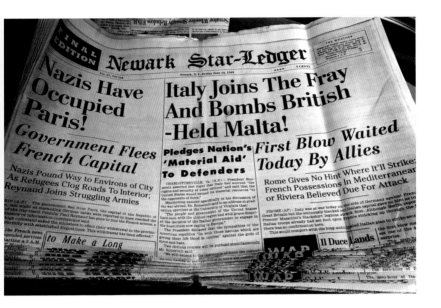

I even checked to make sure that the
weather forecast in the upper right corner
was correct. Not that any viewer would
spot it, but it just felt right.

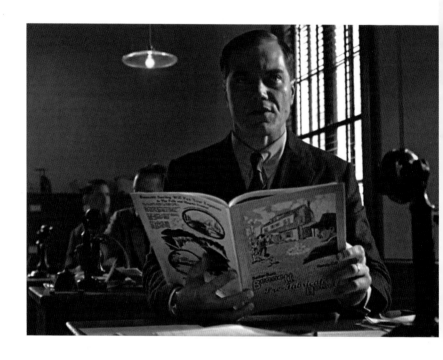

ABOVE:
One of many periodicals for *Boardwalk Empire*. In this scene, Michael Shannon's character daydreams about domestic bliss while at work.

OPPOSITE:
While working on the movie *Joy* (2015), set in the mid-1980s, prop master Vinny Mazzarella asked my advice on how singles connected in that pre-Tinder era.

I explained how periodicals of that time had large ad sections devoted to singles, with a complex system of mailboxes for replies. There were even free singles newspapers that were nothing but ads. I created a faux publication called *Long Island Strictly Personals*, complete with ads featuring period pictures of my wife, myself, and several friends and relatives. Robert De Niro's character uses it to find love.

Biography